HAUNTED OLD FORGE

HAUNTED OLD FORGE

DENNIS WEBSTER AND BERNADETTE PECK

Published by Haunted America
A Division of The History Press
Charleston, SC
www.historypress.net

All photos courtesy of the Ghost Seekers of CNY unless noted.

First published 2016

Manufactured in the United States

ISBN 978.1.46711.879.8

Library of Congress Control Number: 2016933546

This book is dedicated to our friend and our champion in the Old Forge area, Kate Lewis, director of the Goodsell Museum. Without her assistance, as well as that of the Town of Webb Historical Association, this book would not have been possible. Her assistant at the Goodsell Museum, Kristy Rubyor, was very helpful in research and assistance. Peg Masters is another wealth of historical information when it comes to Old Forge and the surrounding area. This work is also dedicated to the wonderful people who reside in Old Forge and the town of Webb. The area deserves the accolades of the world, for it is a charming, warm, beautiful place to vacation and visit. Finally, it is dedicated to the best team of paranormal investigators on this spinning ball of mud: the Ghost Seekers of Central New York.

CONTENTS

OLD FORGE, NEW YORK

Old Forge is located in the Adirondack Mountains, or within the "blue line" that is the border that covers the entire mountain range in the northwestern part of New York State. Old Forge is home to a small base of people but swells to more than 500,000 tourists visiting its rugged charm in the summer and its snow thrills in the winter. Old Forge is nestled next to the Fulton Chain of Lakes, which had been used for a millennium by the Native Americans before the hearty trappers, hunters and woodsmen started to make the area their home. The area proved tough for early settlers, as the brutal winters and difficult growing seasons limited growth, but the area of Fulton Chain and Old Forge proved too beautiful to not keep the hardiest of settlers from staying put.

It all began back in 1798, when John Brown, a Providence, Rhode Island importer, built a mill and dam at Old Forge Pond but realized that the area was not viable for business; the property was abandoned after his death. Brown's son-in-law stepped in and tried to build a business around a homestead in nearby Thendara. He had an iron pit and brought sheep to raise. Wolves ate up the livestock and the mine tanked, with Brown's son-in-law leaving the area in 1825. The abandoned home would be host to Nat Foster, the famous trapper who went on trial for the assassination of Peter "Indian Drid" Waters, resulting in one of the most dramatic trials in the region. Loggers and rugged outdoorsmen couldn't stay away from the beauty of Old Forge, and the area slowly grew. Fulton Chain was the original growth area, but over decades, the population shifted to Old Forge,

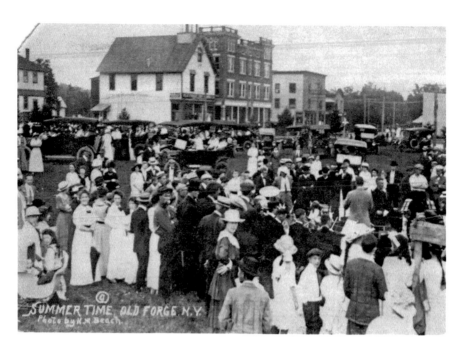

Summertime at historic Old Forge. *Courtesy Town of Webb Historical Association.*

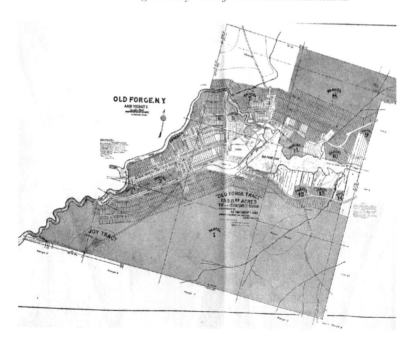

Map of Old Forge. *Courtesy Town of Webb Historical Association.*

nestled next to the beautiful First Lake. Fulton Chain became Thendara and, together with Old Forge, became the heart and soul of the Adirondack Mountains. With train service and a swelling number of tourists, Thendara and Old Forge prospered. Both fall within the town of Webb and today still retain the charm and toughness of the early settlers. Deep among the pines, it is a national treasure.

The region is a paranormal horn of plenty regarding spiritual activity and unexplained phenomena. The Ghost Seekers of Central New York has been conducting paranormal investigations for two decades, yet no town has been as haunted as Old Forge. Every investigation in the beautiful village was overstuffed with spirits and ghosts. Perhaps it's the location next to the pines and water that attracts and retains the spirits of those no longer of this earthly mortal realm. Or it might be the charm and hardiness of the local people who attract the spirits but keep them among the cabins, pines and water.

Irene Crewell is a psychic who is a former member of the Ghost Seekers of Central New York and has been on many investigations, as well as assisted on the haunted walking tours of the town. Her opinion on why Old Forge is highly paranormal is that the area is surrounded by water, which she states is conducive to spirit movement. She says that water is like a "slip and slide" between our world and the world of ghosts. It is a superhighway for spiritual activity. Irene also mentions the fact that much has not changed in Old Forge. There is still one main road through town, and most of the old original structures are still standing. No change, according to Irene, means no reason to move on. She also says that the woods-to-human ratio is large and could embrace and entice spirits to remain in them. No matter what the theories, Old Forge has multitudes of spirits coexisting among the living.

ACKNOWLEDGEMENTS

We wish to thank the following friends, supporters and organizations, as well as all those who assisted us in the investigations and the writing of this book. Thanks to Mike Beck, Victoria Beck, Elizabeth Brigham, Bob Card, Lori Christopher, Peter Christopher, Craig Clemow, Irene Crewell, Nancy Crisino, Charlie Frey, Nancy Frey, Don Gabler, Laurie Gonyea, Zach Gonyea, Brittany Grow, Caryl Hopson, Anne Johnston, Bill Lemieux, Kate Lewis, Peg Masters, Jim Moore, Suzan Moore, Lisa Murphy, Erica Murray, Terry Murray, Susan Perkins, Dave Rubyor, Kristy Rubyor, Rick Surprenant, Tammy Suprenant, Debbie Zembrzuski, Tom Zembrzuski and Helen Zyma. Thanks also to Adirondack Express, Field Zone Photography, Fulton Chain Craft Brewery and ADK Fitness, Herkimer County Historical Society, Maxson House, Old Forge Hardware, Russia Union Church, Strand Theatre, Tony Harper's Pizza and Clam Shack, Town of Webb Historical Association—the Goodsell Museum, Van Auken's Inne and the Woods Inn. And all our friends in Thendara, Inlet and Old Forge, who were always sweet, kind and helpful in our research and ghost investigations.

GHOST SEEKERS OF CENTRAL NEW YORK

W e are a professional group of paranormal investigators specializing in ghost investigation and research achieved through digital audio, video and photography. Ghost Seekers of Central New York was founded in 1999 in Oneida, New York, by Bernadette Peck, our lead investigator, coauthor of *Haunted Mohawk Valley* and *Haunted Utica* and certified paranormal investigator. Our group is passionately dedicated and committed to investigation, research, education and documentation of ghostly phenomena that we've recorded directly through digital audio, video and photography, in addition to our own shared personal firsthand experiences with these paranormal events. The Ghost Seekers of Central New York reaches out to people to help them better understand life after death. We are more than just a club. We are a group made up of caring and passionate members who are interested in understanding the spirit realm and what happens after death. The group wants to help dispel people's fear of death and to demonstrate by solid audio, video and photographic evidence, along with our shared personal experiences, that there is in fact life after physical death. If people can learn to embrace death, they can fully embrace life without fear of death, which can often inhibit people from achieving the most out of their lifetime. Ghost Seekers of Central New York is not a religious organization. We do not in any way favor one religious interpretation of life after death over another. But we do encourage empirical investigation, study and research of paranormal events to help better facilitate one's own personal understanding of life after death. Our investigations, activities and prosperous 1999

Ghost Seekers of Central New York. *Courtesy Rick Surprenant.*

have taken us from Albany to Buffalo to Canada and back again. We've not only been all over the map geographically over the past sixteen years but also have been all over the map as far as the type of venues we've had the privilege of investigating. Our investigations have taken us to every kind of venue, from historical associations to libraries, schools, churches, police stations, jails, farms, apartments, mansions, theaters, restaurants, diners, bars, train stations, hotels and stores, as well as, of course, good spirited cemeteries! The Ghost Seekers of Central New York members include Josh Aust, Len Bragg, Helen Clausen, Judi Cusworth, Paranormal Ed Livingston, Joe Ostrander, Carol Pearo, Bernadette Peck, David Peck and Dennis Webster.

The Goodsell Museum

April 26, 2014—On a spring day in Old Forge, there occurred a rare thing in regards to ghost hunting: a viewing of an apparition. The curious ghost interacted with the Ghost Seekers in the attic of the Goodsell Museum. The Town of Webb Historical Association is based in a lovely two-story red home that at one time had been the residence of George Goodsell and his children, Robert and Tena. When the last of the siblings passed away, he donated the house to the association, but their spirits still cling to their beloved homestead. George had built the stunning red Victorian home in 1899. His son, Robert Goodsell, was a lifelong bachelor who lived to be one hundred years old and passed away in 1994. Tena Goodsell had married and was then known as Tena Goodsell Titus; she had passed away in 1982 at the age of ninety-two years old. The building still has the wonderful charm it was born with and now hosts throngs of visitors and tourists wanting to revel in the past of the town of Webb. The Goodsell Museum building is listed on the New York State and National Register of Historic Places. Kate Lewis, director of the Goodsell Museum, had called about the Ghost Seekers doing a summer talk or program in the museum. Upon questioning, we were told of the ghost of Tena Goodsell Titus being seen in the attic window by people of the town. There were also reports of smelling pipe tobacco in the doctor's office and lights coming on by themselves. Kate made the decision to allow us to investigate; our lives would never be the same.

When we investigate a location, we always do a walk-through of the structure and interview the staff and occupants in order to gather any

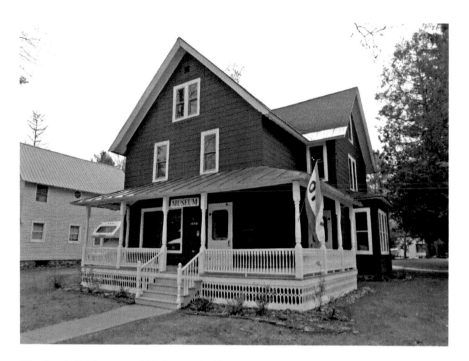

The Goodsell Museum, which houses the Town of Webb Historical Association. Tena Goodsell Titus has been seen peeking out the attic window.

paranormal experiences that they have had. Also, we bring some of our basic equipment to map out locations of false electromagnetism, as well as plan camera placements based on where people had experienced the paranormal. When we walked in, we met Kate and her assistant, Kristy Rubyor. On the walk-through, you could feel the love and lightness of the air. It's one of those things where you feel the goodness. It's hard to explain, but we have a knack for sensing the spirits. Kate brought us around, and they had a display of taxidermied animals and some other Adirondack and Webb historic items. Kate told us about the young girl and her father who were up on the second floor of the museum. There's a small room that had a doctor's table and medical items. The father was out in the hall and had left his daughter in the room alone. He started to hear voices coming from the room, and when his daughter came out, he asked her who she was talking to. She answered that she had been speaking to the nice old man. Her father walked into the room, but nobody was there. Also, Dennis was once down the hall in a room with shelving and storage. There are no windows in this second-floor room, and there was no air moving. He was standing there

when a letter-sized card stock flew off a shelf and hit him in the chest. The spirits were ready to be engaged.

The night of the investigation was a brisk spring evening with the moon glowing between the mist and the budding tree branches. The entire team was present, as was museum director Kate Lewis and psychic Irene Crewell. We set up ghost central in the back office, where there was a large wooden table and archived books and newspapers. It was a perfect vantage point to the paranormal events to come. We started at 7:30 p.m., as it was still getting dark early. We had night-vision video cameras in the attic, second-floor doctor's office, first floor and out at the detached pole barn, where the old Fulton Chain jail cell is sitting, as well as dozens of valuable antiques and historic items. The first team in the pole barn included Dennis, Josh and Dave. They had barely sat down in the old jail when Dave saw a shadow person going across the barn, dodging between a canoe and boxes. Josh felt the presence of a burly man in the jail cell. They started an electronic voice phenomenon (EVP) session with the digital handheld recorder. During investigations, the spirits will sometimes verbalize a response to our earthbound questions. While we were asking questions, we heard ghostly footsteps going through the barn, and the electromagnetic gauss meter spiked up to 1.8. This hand-held device can give an indication of ghostly presence—the theory is that their attempt to manifest to our dimension results in electromagnetic spikes. The seekers did do a walk-through before an investigation to map out false readings that can occur from electrical sources like a fridge or wiring. When the group was leaving the barn, Dennis felt a spider web drag across his face although nothing was there. It was as if a ghost ran its finger down his face.

The group of investigators in the first floor of the museum included Len, Ed, Helen and Skyler, a neighbor of the Goodsells. The group was conducting an EVP session, and Helen was holding the recording device when an unseen entity tried to yank it from her hand. The group asked questions and heard knocks in response, and then when they asked the spirits to come forward, they heard ghostly footsteps on the hardwood floor. Later on, Irene, Ed and Len were up in the second floor, in the doctor's office, when they heard noises in the hallway and smelled something sweet, like pipe tobacco, in the doctor's office. This was a confirmation of previous experiences.

The barn continued to be a paranormal spot, as Bernadette, Joe, Ed, Len and Helen used the flashlight and gauss meter on a question-and-answer EVP session. A large 5.3 spike occurred on the flashlight at the same time footsteps were heard, and the flashlight beam turned on and off to specific questions. Joe and the group heard voices coming from the jail cell "

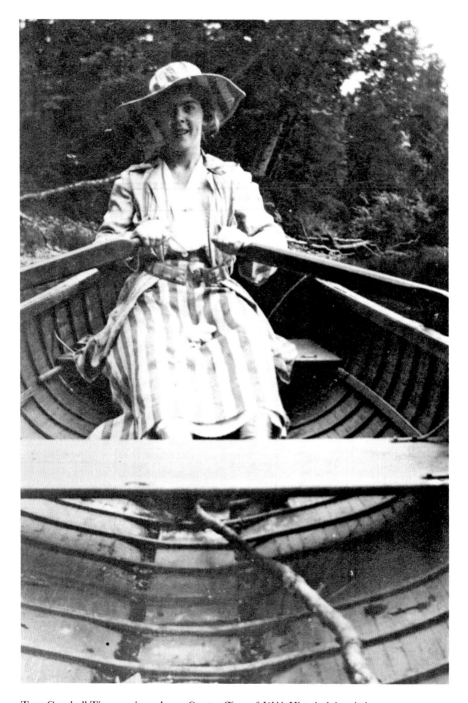

Tena Goodsell Titus rowing a boat. *Courtesy Town of Webb Historical Association.*

The most exciting event happened when we ran into the spirit of Tena Goodsell Titus up in the attic. The public is not allowed up there, but it's not dusty and dirty. It's a finished attic that has rows of shelves that are stuffed with historical Old Forge items, including a creepy doll in an antique baby carriage. Joe, Bernadette and Dennis were up in the attic, and a slight light from the moon was coming in through the front window. Right away, when the group sat down, Dennis felt his throat constrict. A similar constriction had happened to Irene earlier in the night. The three sat down to do an EVP session. There had been reports from people having seen Tena in the window; little did we know that she was about to appear. It started when Dennis saw what was a small entity standing behind a row of shelves. He could see a small female shadow figure peeking around at the group. Dennis asked, "Bernadette?" and she answered, "I see her peeking at us." Joe could not see her as he was tucked back in the corner and didn't have a view. "Come closer," said Bernadette. "Don't be afraid." A minute later, they saw Tena within ten feet peeking over a stack of items. It's rare to see a shadow person on an investigation, let alone an entity that intelligently interacts with you. When the group came downstairs and told everyone what had happened, Josh smiled ear to ear. He went on to say that he had the same interaction with the ghost of Tena earlier in the night. He had kept quiet about it to see if anybody else would meet her. It's common for spirits to hang around in their beloved home, even after leaving the earthly world.

BERNADETTE'S TAKE: Old Forge had always been on my list of places that I had wanted to take my team to investigate. The area is beautiful and alluring and has a paranormal attraction. I'm not sure if it's the mountains, the lakes or the wonderful people who live in the area—people like Kate and Kristy. They welcomed the Ghost Seekers and let us investigate their beautiful museum first. It was a great start, with a lot of team members having direct physical, visual and audible contact with the spirits. Interacting with the ghost of Tena in the attic was among the most memorable otherworldly interactions I have ever experienced in more than fifteen years of investigations. It's a wonderful feeling to experience a haunting but also confirm paranormal interactions that citizens have had in the Goodsell Museum. Kate reported to me in the aftermath of the investigation that doors started opening on their own and footsteps would be heard. I encourage the public to visit the museum. For the price of admission, you get to see fantastic Old Forge history, but you might just get a ghostly greeting from Tena Goodsell Titus.

OLD FORGE HARDWARE

J.UNE 7, 2014—When you visit Old Forge in the summertime, you will always see a massive crowd of tourists, visitors and townspeople filling the aisles of the Old Forge Hardware Store. At night, the ghost of the original owner, Moses Cohen, has been seen by locals strolling the store looking over the merchandise. The Old Forge Hardware Store was started when Moses Cohen came to the town in 1900 as a peddler of all sorts of goods needed by those with hardware requirements. Back then, there was barely more than a dozen buildings making up the village of Old Forge. Moses purchased a corner lot in 1902 and built his store, which became a smashing success with the locals, as it saved time and shipping costs.

Disaster struck in 1922 when a fire burned down the original building. It was said that the fire was difficult to fight, as boxes of bullets, lit ablaze, were snapping off and whizzing by the firefighters. Moses rebuilt and stayed committed to Old Forge, with the grand reopening on Memorial Day 1923. Moses had longtime, dedicated staff members like Hank Kashiwa, who managed the store for Moses for fifty years. In 2000, Mike Wilcox managed the store along with his daughters Sarah and Linda Cohen. The store continued to expand with a vast array of goods, along with a bookstore that attracts authors from around the country. Mike Wilcox's daughter Erica and her husband, Terry Murray, became the new owners in 2008 and continue to run the store to this day. It was Erica who opened the doors to the Ghost Seekers of Central New York to investigate the beautiful and historic business.

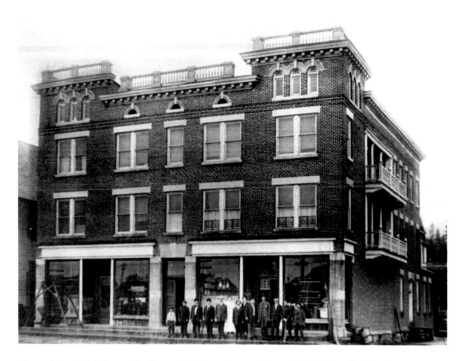

The original Old Forge Hardware building. *Courtesy Town of Webb Historical Association.*

The Ghost Seekers arrived on a sunny and warm June evening all excited and ready to investigate. Bernadette had a phone conversation with Erica ahead of time, and she talked about the locals seeing Moses walking the aisles late at night when the store was closed and dark. The team brought its entire bag of gear, as the store is massive. Ghost central would be right near Erica's office and the main cash register near the front doors. The team marveled at the beauty and massive amount of inventory that stuffed every inch of the marvelous structure. We had to wait for Erica to close the store on a Saturday evening before we could set up the gear. We had night-vision video cameras placed in the bookstore, the aisle where Moses was witnessed, the mezzanine and the back storage room. All are hard-wired to a large flat monitor so we could have one investigator watch and record any paranormal happenings. There were two teams investigating two distinct areas of the store at the same time. Both had one person with a hand-held night-vision video camera. In addition, each team had a handheld digital recorder, flashlight, gauss meter to measure electromagnetism and digital cameras.

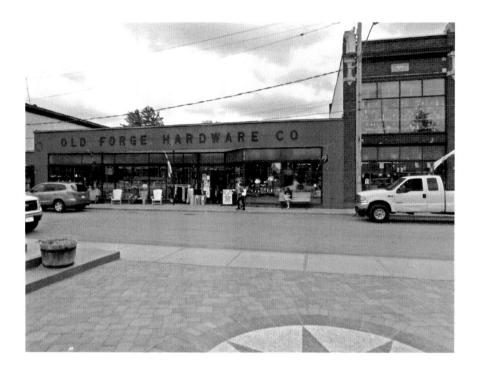

Above: Newer building of the Old Forge Hardware, with the bookstore in the back.

Right: Moses Cohen, founder of Old Forge Hardware. *Courtesy Old Forge Hardware.*

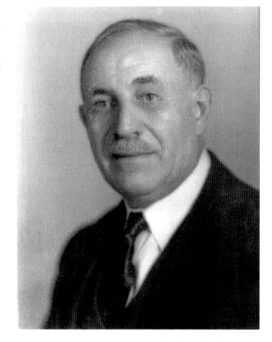

Erica locked us inside and would come back later in the night. She left just as the sun was hitting the rim of the pine trees; shadows flirted with the edge of night. It was during the setup that Dennis had a very freaky paranormal occurrence in the back storeroom. If you go up in the mezzanine area of the oldest part of the store, back in the corner there is a door that the public is not allowed to enter. Through this door there is another building connected that has shelves and houses extra inventory, the original Old Forge Hardware sign and various decorations and display items. It is very neatly arranged, and the aisles are clear. The floor is old wooden slats of a light color. Dennis was alone walking the area, checking on the wiring to the video camera. He was walking looking down at the cord on the floor, as the seekers will tape loose wiring if it is a tripping hazard. He walked down the middle aisle, looking down, and saw nothing. He turned back around, and there was a little, flat, black plastic object now sitting in the middle of the aisle. He picked it up, and it was an old negative from a 35mm picture. He brought it downstairs, held it up to a bright lamp and saw that it was a photo of four girls, with two who looked to be twins or very closely resembled sisters. Dennis took the negative and had it developed into photos, and neither Erica nor anybody else in the store could identify who the girls were in the photo. Kate Lewis and the crew at the Goodsell Museum could not identify them, and neither could some longtime residents of Old Forge. What were the ghosts trying to say by leaving this negative? The photo is printed in this book in the hopes that somebody out there will identify the mysterious girls.

Bernadette always says that if you are experiencing the paranormal during setup the investigation is sure to be an active one, and she could not be more correct. The team that night consisted of Bernadette, Dennis, Len, Helen, Irene, Josh and David. Erica was kind and trusting enough to leave us alone in her beloved store. We were honored to be there and anxious to see if we would contact the ghost of Moses Cohen. We gathered in our circle, held hands, closed our eyes, bowed our heads and recited our prayer of protection. The seekers feel that we receive great interaction with the other side because we approach every investigation with peace, love, respect and good karma. There's no proof, but we do feel that the spirits can be like children or animals—they sense loathsome and mean people and gravitate toward happy, open-minded people. We were happy to be in the Old Forge Hardware Store and anxious to meet and greet the ghosts.

The first team included Bernadette, Helen and Len, who went to the bookstore section of the store. Dennis and Len had heard footsteps in the bookstore when they had been setting up the static night-vision video

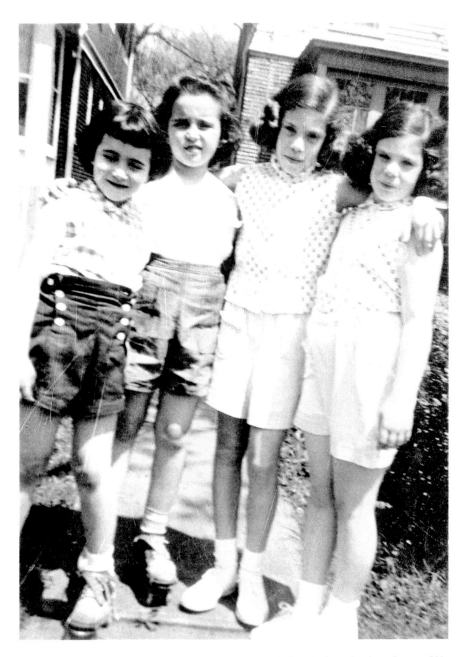

Do you know the mystery girls? A ghost left this photo during the investigation. *Courtesy Old Forge Hardware.*

camera, and the team was eager to see if it would be replicated. When a spirit repeats the same incident over and over, it is called a residual haunting. It's like a tape recording playing the same paranormal imprint over and over. When there are ghostly encounters that are interactive and responsive, they're called intelligent hauntings. The session in the bookstore would prove to be intelligent, as the team asked questions and received responses in the form of an illuminated flashlight. The team also heard footsteps in the dark, as a ghost had been walking the bookshelves. Bernadette witnessed a white light that was not of this earth; it was spooky and unnatural. Helen went to investigate and witnessed a shadow person moving from right to left past the bookshelves.

Josh, Irene and Ed went to the oldest part of the store and up on the second-floor mezzanine. Josh and Irene had both felt sharp pains in their heads during the sweep, giving an indication that there could be something ready to interact with the living. During the investigation, Josh and Irene got numbness and swelling in their hands, so much so that when they tried to take off their rings, they could not remove them. Josh and Irene both felt connections happening with entities, and Josh felt that the name Natalie

Mezzanine at Old Forge Hardware, where shadow people were witnessed.

was important. At this point, he felt pressure on his throat. Ed reported hearing noises, knocks and walking. The store was locked and empty, so the team knew that there were ghost shoppers and visitors strolling around the building.

The first round had ended, and the team was excited at the great start. The team was taking a quick break when Bernadette witnessed Dennis walking across the mezzanine followed by three shadow people trailing behind him—otherworldly observers curious at the living in their nightly realm. It's amazing how a paranormal event can happen when you least expect it or ask for it. The second round of investigations yielded very little results in one area but fantastic results in another. Josh, Helen and Len headed down into the cellar and reported feeling odd and hearing strange acoustics yet nothing else. This shows that not all investigations or areas yield paranormal activity. On the contrary, most of what the ghost seekers do is spend hours and hours with nothing being revealed. The ghosts answer to their own validity and in accordance with their own feelings and time frame. The second team had better otherworldly luck.

Bernadette, David, Irene and Dennis went into the back storeroom, where the picture negative had been left for Dennis. Right away, Irene gleaned the name of a little girl named Abigail and had the image of her waiting for her father to finish stocking the hardware store shelves. Right after this, something brushed up against the arm of Dennis. The group settled down and sat in some old wooden chairs to conduct an EVP session. They also placed a flashlight next to the recorder to see if any paranormal energy would light it up in response to questions Within seconds, walking and movement were heard coming from the other row of stored goods in the dark storeroom. Everyone mentioned that they had goose bumps. Right after this, Bernadette witnessed a shadow person walking across the aisle. A shadow person is perceived to be a ghost but in a form in which is hard to make out specific details. It's as if your shadow was up walking around independently but intelligently. David then asked if we had Moses with us, and nothing happened. When Bernadette asked if it was Indian Drid, the flashlight lit up. It shut right off afterward. David again asked if it was Moses Cohen, and nothing happened. Again, the ghost was asked if it was Indian Drid, and light turned on. The flashlight continued to illuminate in response to being named Indian Drid. The assassination of Indian Drid is well known in the town of Webb, as he had allegedly been shot and killed while in his canoe in First Lake in the nineteenth century. It was the tragic conclusion of a dispute with Nat Foster. The lake is just behind and down the hill from

Spirit light floating in the merchandising rows at Old Forge Hardware.

the Old Forge Hardware Store. It makes sense that the spirit of Indian Drid would wander the beloved marketplace. The last incident, right at the end of the investigation, was when group started feeling freezing cold. Sometimes ghosts affect the temperature; this was a warm and muggy June night in a closed room with no windows, doors or air conditioning, yet it became bone-chillingly cold. The groups got back together at ghost central and revealed their experiences over coffee and candy bars. Another investigation was completed at a wonderful business in the heart of Old Forge.

BERNADETTE'S TAKE: I have been hunting ghosts for most of my life, and I like to think that I know when a place has a great paranormal aura. I have always been very fond of the Old Forge Hardware Store, and just walking through the business midday, with it packed with shoppers, I could feel the energy of the other side. I was pleased that our investigation proved my spiritual intuition. Erica Murray could not have been a better host, and ghosts will gravitate toward those with a positive karma. My team of Ghost Seekers can 100 percent certify the Old Forge Hardware Store as haunted, but not by anything other than loving, caring, interested spirits like Moses Cohen.

TONY HARPER'S PIZZA AND CLAM SHACK

JULY 19, 2014—The rooftop music and bar spot is only one of the best parts of Tony Harper's in Old Forge. There's also a ground-level pub, a backroom deli, apartments for rent and ghosts on the menu. The building is built on the area where the first Old Forge Post Office had been, along with a private residence. These structures had been torn down and replaced with the Tony Harper's food and drink location. The building next door had an old preacher's rectory moved over and attached in the 1930s. This building is where the apartments are for rent and where travelers and some of the staff reside. It was where the number-one haunted apartment exists.

When we talk to people about finding ghosts in buildings that are relatively new, people will marvel at this, wondering how there can be spirits in a new structure. Please keep in mind that new buildings are sometimes built on sites of hallowed ground, spiritual portals, long-lost graveyards or new structures built on the soil of torn-down or removed buildings. This was the case with Tony Harper's; we were honored to investigate a place where the Ghost Seekers of Central New York have feasted on wings, burgers and pizza, as well as sipping on a few cold brews. Lisa Murphy, owner of Tony Harper's, invited us to come in and conduct the investigation. She told the group about the ghost called Sam that throws things at staff and shoppers in the deli.

The night of the investigation was a gorgeous summer evening, but we would have to start the investigation much later, as Lisa had to close the bar and clear out her customers. The ghost hunt would not start until 1:30

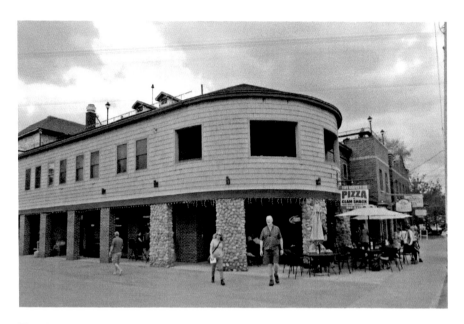

Tony Harper's Pizza and Clam Shack.

a.m. The crew would be small: Len, Irene, Ed and Dennis. We met Lisa in the deli, where she had some of her staff come and tell us of their ghostly encounters. Everyone enjoyed the tale of Sam the spirit, which hangs out in the deli, but the spirits existing upstairs in apartment no. 1 seemed darker and more devious. The first employee was a waitress and told us that she had never felt comfortable in apartment no. 1 and had a scary experience while taking a shower. She had heard footsteps when nobody else was in the apartment, but she never saw a solid human. She was taking a hot shower, and the bathroom filled with steam. When she stepped out of the shower, there were two large male handprints on the bathroom mirror.

Another waitress also stepped forward to tell us about the hauntings in apartment no. 1. She had been staying there with her fiancé when things kept happening, but with more frequency and intensity, until a final encounter forced them to flee to another apartment. She said that her fiancé would get up very early in the morning, and that's when encounters would happen. Things would move, she'd hear footsteps and one time she witnessed a plate moving. She'd hear giggling in the other room and jump out of bed to check, but there would be nobody there. The couple had a dog, but he was always in his cage when these things would happen. Another time, when her fiancé was gone, doors were opening, and she'd

heard doorknobs jiggling. She had said aloud, "Please stop doing this," and a plate flew against the wall. The final incident happened mere days before the investigation. She was again alone, as her fiancé had left, when she heard footsteps coming toward her. She was awake, and she said they got louder and quicker until they were right next to her bed. It was at this point that she felt icy-cold ghost fingers clasp on her throat. As she was telling the Ghost Seekers this story, she became overwhelmed with emotions and started to shake and quiver. There was no doubt that we were dealing with an angry spirit that didn't want people in its domain.

Lisa introduced the group to her nephew Leon, who asked to come along with us on the investigation, and we agreed. He sat on a stool in the deli and told us his encounters in room no. 1. He had stayed there for one week and said that he had never slept. Leon would wake up from furniture sliding and moving all by itself. He felt like he was always being watched, and one morning he woke up and a chair was placed right next to his bed, as if a ghost had slid it over during the night, sat in it and observed him sleeping. The last night, Leon felt that he was being watched, and he witnessed a ghost of a man standing in the corner of the bedroom watching him. He swore that he would never step foot back into apartment no. 1 again, but he did agree to go along with the Ghost Seekers. He made the joke that we would be using him as ghost bait.

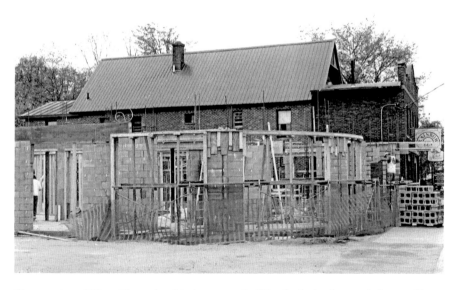

Construction of Tony Harper's, with the rectory building in the background. *Courtesy Town of Webb Historical Association.*

We got started on the investigation close to 2:00 a.m., and Old Forge was quiet to the point that you'd hear a cricket click its heels from a block away. We decided to head right up to apartment no. 1 since it was unoccupied. Leon tagged along the rear of our group, and right away Len received a large spike on the EMF meter. This device captures spikes in electromagnetism, with the theory being that unnatural spikes can be an entity present or trying to form into our dimension. We walked upstairs and went right into apartment no. 1. We had heard that nuns had also lived in the old rectory. We went into the bedroom where Leon had his encounters and where the girl had been choked by a spirit. It was very dark, and we could barely see. We all sat on the beds except Ed, who was on the floor near the closet. It was only a few minutes in of channeling the spirits when Irene heard footsteps coming from the kitchen area. Dennis confirmed this, and the digital recorder picked it up. While this was happening, the closet door near Ed swung open and Leon swore in excitement. Irene calmed him down and told him to maintain his decorum. We try to always remain calm and professional on a ghost investigation. Right after this, the entire group could hear creepy breathing from the other room; Irene said the word *father*, and the breathing increased in frequency and volume. It got calm for a few moments before Dennis saw a black shadow moving across the ceiling. Then it came down and brushed against him.

Irene felt that it was the presence of a priest who was not dark or evil but rather grumpy and upset that we were bothering his domain. Irene felt her stomach get queasy, and Len heard a knock that we picked up on our handheld digital recorder. We then moved out into the living room, and the knocking and footsteps continued. The group decided to move back downstairs and see what we could get in the bakery. Perhaps Sam would come out and say hello. When we were in this room, Dennis happened to look at the security monitors from the Tony Harper's ground-level bar and witnessed an intelligent orb moving from liquor bottle to liquor bottle. Len decided to reach out to his friend Al who had run a business near the bar and had recently passed away. As soon as Len asked for Al, the temperature dropped and held at seventy-four degrees on the handheld temperature meter before going back up. At this time, Irene felt that it was Al, and her stomach was hurting. Len asked if it was Al and whether he could please replicate the temperature drop. At that point, the temperature went back down and held fast again at seventy-four degrees. Len got a chill and then asked Al about passing away from pneumonia, and there was a ghostly cough that was captured on the handheld digital recorder. It was a sad way

A strange paranormal smear at the time of a priest channeling with psychic Irene and Paranormal Ed.

to end the night, as Len's friend had come by to say one last goodbye. It was pushing close to 5:00 a.m., and Lisa came back as we were starting to pick our gear back up. Lisa was kind enough to offer one of us to spend the rest of the night in apartment no. 1. Although we were all tired, we all passed on the offer, as everyone had been spooked by the angry priest. Although people think that ghost seekers are fearless, nothing could be further from the truth. We have all the human emotions that come with our existence on this plane, and fear is the strongest. We said goodbye to Tony Harper's. If anybody wants to challenge fate, go ahead and ask Lisa for the keys to apartment no. 1.

BERNADETTE'S TAKE: This was one of the few investigations that I have missed in my career, but I was excited to hear the details from my team on what had happened during the investigation. Even when I sat in a booth with the seekers eating, I could sense the spirits wandering the bar. I could feel the strong paranormal aura even in a crowded restaurant. A year later, when the seekers were conducting a ghost tour of the haunted locations in Old Forge, a young man approached us and told the group that he was staying in apartment no. 1 and that every night he was awakened at 3:00 a.m. by footsteps or knocking. He was suspicious as to why this activity had been occurring, so he looked under the bed and discovered a Ouija board. We advised him to get rid of it, as it was not just a board game but rather a device that opens a gateway; when you are opening a paranormal door, not just friendly spirits might walk through.

Strand Theatre

July 2014—Of all the locations and buildings in Old Forge, the place locals point to as a haunted beacon would be the Strand Theatre. In the past, Dennis had attended the annual author fair put on by the Old Forge Library. Every time he was at his table selling books, locals would stop by and discuss the Strand Theatre and the tales of its haunting. One elderly, soft-spoken lady mentioned seeing a ghost looking out the front top window at her. The Strand building has been an icon since the Thomsons built the structure and opened it on March 15, 1923. The Strand was said to have held seven hundred moviegoers when it opened, and the first movie to show there was *The Old Homestead*, an eighty-minute silent film that had been released in 1922. The silent movies were shown with an accompaniment on the piano by Mrs. Walter Farmer. The Strand Theatre still showed movies, but there was also a barbershop on the first floor during the time the structure became known as "Brown's Strand Theater," when Old Forge businessman Harry Brown took over. Back then, the ghosts were probably pleased that he showed the black-and-white horror attraction *Frankenstein*, when Harry charged thirty-five cents to see the feature and large boxes of candy were only a nickel. It was said that his wife, Mrs. Luella Brown, was a small lady but large in toughness; with her as the usher, no tomfoolery was allowed. A tragic accident claimed Harry Brown's life when on July 7, 1962, he was walking along Eagle Bay Road when he was struck and killed by a logging truck. Harry had come from Forestport, New York, and was a business fixture in Old Forge for more than fifty years. When the Strand

plus the Brown Gift Shop, Brown's Garage and Taxi and a skating rink and dancing hall. He originally showed silent movies at the Masonic Temple in Old Forge before moving them to the Strand, but it's the latter where his spirit is said to walk the seats and rows smoking his iconic cigar.

The Strand Theatre was bought in 1991 by Bob Card and Helen Zyma, who upgraded and improved the business. For more than two decades, they have lovingly shown movies to locals and Old Forge tourists, with Bob and Helen often working the ticket booth. They were filmed talking about the ghost of Harry Brown haunting the Strand. Adirondack Mountain Productions filmed a program titled *The Strand Theatre: 90 Years in Old Forge*. About eighteen minutes into the video, we see Bob and Helen sitting among the seats, talking about the many times when, closing the theater for the night, they have felt a presence. Many times, they have gotten a paranormal whiff of Harry's cigar. Bob smiles at the camera and says, "The ghosts of Old Forge still go to the movies."

Bernadette and Dennis decided to pay a visit to the Strand Theatre to inquire about the ghosts. They had heard more tales from the locals of ghosts occupying not only the theater but also the upstairs apartments. When they

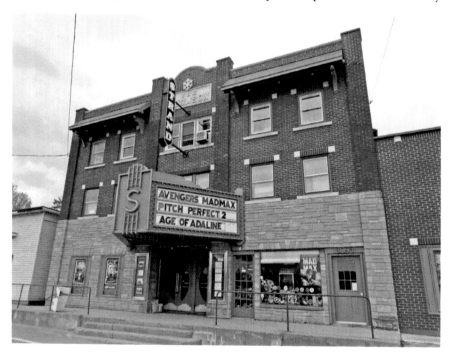

Strand Theatre, with the marquee displaying the latest movies.

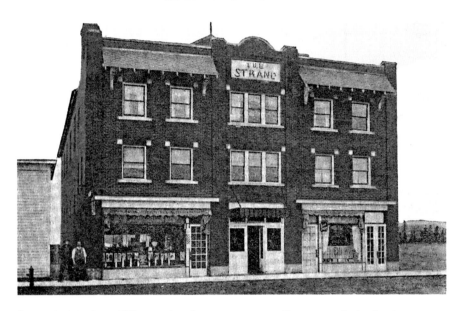

Postcard of the Strand Theatre that shows two men standing next to the barbershop. *Courtesy Town of Webb Historical Association.*

walked into the Strand, Helen was selling the tickets, and a teenage employee was working the candy and popcorn counter. Helen was kind enough to come out of her booth and speak with the paranormal investigators and tell them firsthand of the haunted happenings. She spoke with a sweet tone that evoked a gentle soul, and her smile was warm and engaging as she mentioned a group of old ladies fleeing the theater when they had seen a ghost. Others have mentioned hearing a ghost playing the old organ piano from the silent movie era. Helen mentioned the strong odor of cigar smoke that would occur every once in a while, especially down near the front of the theater, as if Harry were strolling the rows of his beloved movie house. She mentioned that in the upper apartments, things move and a presence has been seen. Dennis and Bernadette smiled, appreciative to hear the stories.

Helen then described how there is a pull chain in the theater, and for no reason it has been seen swinging to and fro. There was no wind or anything else that could move it. She also said that the theater is prone to hot and cold spots, which is a common occurrence in the presence of a spirit. Helen paused for a moment, smiled and then told the story of the ghost of Harry Brown coming to her defense when she had a disagreement with Bob. Harry's ghost hugged her with a paranormal embrace as if to say he supported her side. When Helen was done speaking of the haunted

happenings, Bernadette strolled over to the candy counter and spoke to the young man working. "Have you seen any ghosts?" she asked. The young man's smile went away, and with a scared look, he said, "I'm not saying anything." Bernadette tried to reassure him that it was all right to talk, and he said, "There is no way you're getting me to talk about anything to do with that stuff." Dennis and Bernadette asked Helen if the Ghost Seekers of Central New York could conduct a paranormal investigation within the Strand Theatre, and Helen graciously said no. She explained that she was afraid the group would stir something up. The seekers respected her decision, as a building owner has to be comfortable with an investigation, and many do feel that something might be stirred up. Dennis and Bernadette thanked Helen for her time and took a moment to take in the grandeur of the Strand Theatre. It will always be among the top places the seekers will want to investigate. Just remember that when the lights go down and the movie lights up the screen, the whiff of cigar smoke might just be the ghost of Harry Brown sitting in the seat behind you.

BERNADETTE'S TAKE: I respect Helen and Bob not wishing us to perform an investigation. They have people who live in the building, and we cannot guarantee that spirits will not get aggravated. That's why the Ghost Seekers tend to shy away from homes where living people reside. Spirits can be asked, but they are not loyal companions or easily manipulated. They are unpredictable and stubborn, much like us.

MAXSON HOUSE

May 22, 2015—On a cool, windy night at the end of spring, the Ghost Seekers of Central New York investigated what might just be the most haunted place in Old Forge. That is quite an honor, considering that almost every building the seekers have stepped into in Old Forge has had an abundance of paranormal activity. Forget Salem—if you wish to encounter the biggest ghost bang for the buck, come to Old Forge, and your starting point needs to be the Maxson House. The Maxson House is owned by Lori and Peter Christopher and has a long and tragic history. The building was erected in the late nineteenth century, and the Tennis brothers operated it as the Adirondack Boarding House. At the turn of the century, it was sold and became the Adirondack Hotel. Over the twentieth century, it has had many names: Hotel Cleaver, Maxson House, Pinto's and Brindisi's. During this time, a fire took the entire building. It was rebuilt, and a person lost his life in a tragic gun accident. Some say it was Russian roulette and others a tragic accident that took the life of a young man. It was reported that a local constable came into the building waving his gun and threatening to shoot patrons. It was then the Old Forge Inn, before it became a longtime antique store called Antiques and Articles, which was the name until the current owners, Lori and Peter, purchased the building and named it Maxson House in tribute to the old name. In its current incarnation, paranormal activity runs rampant and had the owners asking the Ghost Seekers to stop in and investigate.

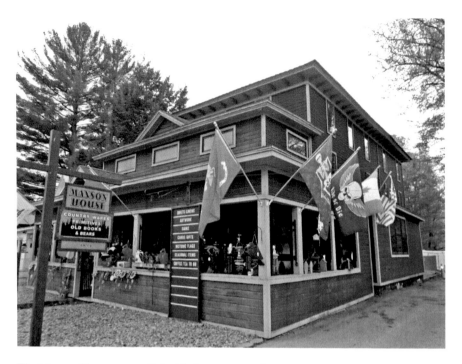

The Maxson House, overstuffed with the paranormal.

Some of the events happening included shoppers having books tossed off the shelf at them by ghosts, garland flying at them and other events just in the daytime in a crowded store. The owner, Lori, had many stories of experiences that she and her loved ones had been having in the beautiful structure. One time, she and her husband captured on the store's night-vision security camera a large strand of garland being pickup up off a hook and thrown across the merchandise aisle. Lori has seen the entity of a man in a pinstripe suit but with no head. Up on the second floor, she hears a little girl ghost singing and humming. This has happened when Lori was all alone on the first floor doing paperwork; the store was closed. Another time, the little girl called down, "Lori," in her sweet, otherworldly voice. Her sister-in-law, Laurie Gonyea, had encounters, as did her son, Zach, while working alone in the store. Zach had heard a voice summoning him up to the second floor; he strolled up the steps only to discover that there was no one there.

Lori has seen a tall thin male ghost with glasses she calls Henry. Down in the basement, where the extra inventory is kept, is a far back corner stuffed with antique books. In this area, Lori had seen the spirit of an elderly woman in a

shawl. All these occurrences are sprinkled with constant sounds of footsteps up and down the staircases and on floors above. One paranormal incident was family-oriented and very emotional. The Ghost Seekers listened intently as Lori and her husband, Peter, told the details. When they had first opened Maxson House, they had doubts and had even asked aloud, "Are we doing the right thing?" On the first floor of the business is the retail store, and in the back right corner the bookstore. There is a little wooden table there, and one day, when they opened the store, they noticed a book sitting on the table that had not been there before. They knew right away that it was their dead uncle's favorite prayer book—opening the inside cover confirmed it. The message had been sent, and the emotional lift reassured the Christophers that they were doing the right thing and successfully moved ahead.

The scariest incident was the large male ghost that hangs around the third floor, where Lori and Peter live during the summer. Lori's mother had come to visit and had been saying that the male ghost was a figment of their imagination. A previous sleepover of Lori's sister had proved frightening—when the sibling was asleep, she felt a ghost get in bed and spoon her. Well, the skeptical

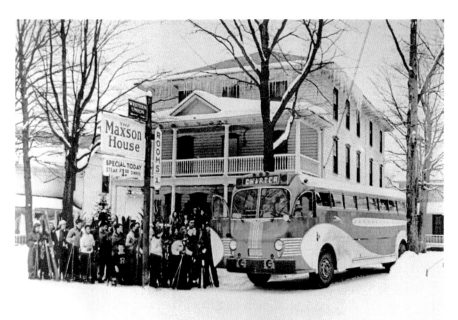

Skiers wait outside the Maxson House. *Courtesy Town of Webb Historical Association.*

grandmother went to sleep in the same bed up on the third floor, only to be awakened by the same large male ghost sliding into bed with her and hugging her. She sat up the rest of the night with the light on and has sworn to never return to the Maxson House. There are so many paranormal incidences at the Maxson House that the team of ghost hunters was astounded. One time, Lori had noticed a missing sterling silver earring. It was in a locked case, and only one of the pair was missing. A year later, she smelled something rotten in the basement and told her husband, thinking that there was a dead mouse down there. He went down, but the putrid scent overpowered his nostrils. Suddenly, the stench disappeared. He looked down, and there was the missing earring. Lori calls this entity "Mr. Stinky," as he spreads his nasty odor every once in a while but usually in the basement.

The Ghost Seekers were anxious to get into the Maxson House, and most of the team came: Bernadette, David, Dennis, Ed, Len and Joe. We were greeted by Lori, who had additional paranormal events happen within days of the investigation. On the first-floor merchandise area, there is a row of stuffed animals. In the morning, she and her husband came down, and there were several lined up on the floor, as if the little girl ghost had taken them down to play with and never put them back up. Peter had come downstairs another morning and found books on the floor, all spread out, as if the entity had again decided to occupy herself in the witching hour with some literature. Some theories offer that ghosts wander our world instead of moving into the light, as they yearn for the pleasures of our world, whether it be human interaction or the simple joy of cracking open a book. The structure was overstuffed with paranormal hot spots, so Bernadette did a walk-through with Lori to map out the best locations for the night-vision video cameras. The Christophers left and let the seekers have the building all to themselves. Our spirits were high in anticipation that we would receive some of the paranormal activity that had been occurring.

Ghost central was placed in a room on the second floor, where David sat for the night, navigating the monitors of anything ghostly moving in the darkness. There were several night-vision video cameras in a variety of places. The rest were broken into two teams, with each team carrying a handheld night-vision video camera, digital cameras, EMF meters for measuring electromagnetism and handheld digital recording units. Before the team launched the investigation, the members held hands and said a prayer to St. Michael to protect them from the evils of the spiritual world and bring forth only friendly spirits. This prayer is usually successful, but the night at the Maxson House would prove to be anything but typical. The first

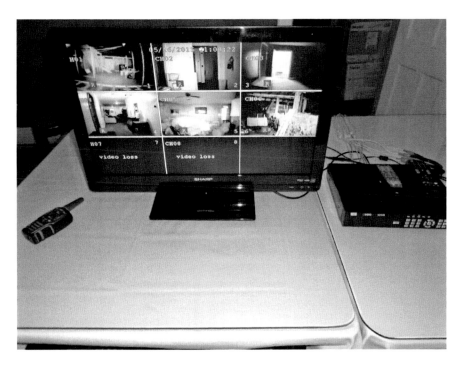

Ghost central, showing night-vision camera feed. Shadow people and spirit lights have been caught on this system.

team consisted of Josh, Bernadette and Dennis, who headed down into the basement. The second team consisted of Joe, Len and Ed, who ascended to the third-floor living quarters.

The basement was so dark that you could not see an inch past your nose. The group shut off the flashlight, placed down the devices and started to ask questions of the spirits. The group first stopped at an area in the basement where there was a lot of inventory items. Right away, Josh got a headache, and Bernadette felt that something was confused in the basement. Right after these statements, the temperature dropped two degrees, and the gauss meter spiked. The flashlight had been turned off and set on a shelf. Bernadette asked if there was something with the group to reach out and touch the flashlight—to use its energy to power it up. The flashlight illuminated. The group moved on to the book area in the basement where the ghostly elderly lady appeared in her shawl. Within a minute, Josh got the name Cassandra, Bernadette had all the hairs on her neck raise and the REM pod spiked up to an unnatural 9 reading. The group settled down and was asking questions and then Dennis felt

something cold on his back, followed by a growl. Bernadette's leg started to shake. Josh asked, "Are you controlled by something down here?" and right away Dennis felt something brush his cheek. As the team was leaving the basement, an animal snort was heard and picked up on the digital recorder. It was loud and eerie. The team went up to the first floor, where all the merchandise was and where the garland's movement had been seen. Within seconds of settling in, Bernadette was startled by a ghostly head of a man floating and bobbing. Could this be the missing head of the headless entity previously seen by Lori? Bernadette is always professional and cool, even in the face of grumpy spirits, yet the vision of a head drifting into the earthly realm startled her. She quickly settled down, and footsteps were heard up and down the aisles; the floor vibrated under Bernadette's feet. The Maxson House was living up to its reputation.

Team two went up to the top floor, where Lori and her family live during the open season of the Maxson House. It was in the master bedroom that the group noticed the temperature dropping and stopping at 66.6 degrees. This is when the group gave the name to the male entity that they felt was in the room: "Mr. 666." He was rather grumpy and gave the team an uneasy feeling. The temperature stayed at 66.6 degrees the entire time. The team reported some interesting orbs in some of the photography.

The teams regrouped at ghost central, where David commented on the sheer number of spirit lights intelligently fluttering in and out of the rooms and merchandise rows in the store. After a quick break, the teams again broke up into two, with Dennis, Joe and Len staying on the second floor while Bernadette, Ed and Josh headed up to the third floor, where the previous team had encountered Mr. 666. Dennis, Joe and Len went into a small room with wood paneling that was empty except for a few boxes of merchandise. On the previous round, Joe had seen a shadow person moving in this room. Dennis had his gauss meter. When there is a spike, the device lights up with a bright red flash and blats out an audio alarm. Within seconds of walking in the room, the device started going off. Len and Joe started to ask questions and were getting specific responses from a spirit they felt was the little girl. Dennis does not claim to be a psychic and rarely has flashes, but he did get the name Pumpkin for the little girl ghost. When he asked if that was what she was called, the ghost meter blared. From then on, she responded strongly to questions using her name. Joe asked if she knew her mom and dad, and the ghost meter blared. Dennis asked if she liked the owner Lori, and the ghost meter shrieked at full strength.

The group decided to go out into the large room outside the one it was in. On the way out, David sent a message from the walkie-talkie saying that there was all sorts of activity on the night-vision video camera in the area. When the group walked out, Len was last out of the room; behind him, Pumpkin cried out in a paranormal whimper that was heard by all and picked up on the digital recorder. The team decided to go down to the first floor and went into the bookstore area, where there had been books thrown off the shelves at shoppers. The group asked all sorts of questions, and Joe felt something touch his back. At the time, the group did not hear anything, but upon review of the digital recorder, there was the sound of a child's toy piano playing—several keys being tapped by ghost fingers. The Ghost Seekers did not know it, but there was a toy piano in the basement. Nobody had seen it, and when the keys were played, the rest of the team was up on the third floor. Only in the review did we discover there was a piano in the basement. Lori, the owner of Maxson House, was astounded. During the review, her husband went into the basement and played the piano, but you could not hear it in the book room. It's an amazing piece of paranormal evidence.

Joe and Len in the midst of an interaction with the ghost of Pumpkin at the Maxson House.

Joe, Len and Dennis went into the aisles of the store and right away were seeing a shadow person watching at the end of the aisle. They tried to get it to come closer, but it would not. The REM pod and the ghost meter were blaring away, and the group kept hearing footsteps in the aisles next to where they were standing. It was a paranormal hide-and-seek with multiple entities curious about us being in their area in the inky-black nighttime. The witching hour was theirs, and they were not afraid but nonetheless were watching every move of the investigators. The strongest reaction occurred when the group stopped by the stuffed animals. We asked if it was Pumpkin following us, and we received a resounding yes from the gear. Joe asked if her favorite toy was there, and the ghost meter blared as if she had touched it with her little otherworldly hand. Joe and Len heard humming, which is what Pumpkin does all the time when she is alone in the store with Lori. It's important to note that during the pre-investigation walk-through and the earlier investigation in the store area, the REM pod and the ghost meter never went off. The strong interaction with the devices confirms ghost communication.

The last investigation of the night was when the entire group went up to the third floor. David once again stayed behind to man ghost central. The seekers settled into the master bedroom, as that was where Mr. 666 had made his presence known, and it took only seconds for him to come back. The ghost meter and REM pod started to click, but the temperature sank down to 66.6 and stayed that way until the group left the room. Bernadette felt cold, and Josh was uneasily looking in the antique mirror in the room. Lori had stated that the mirror came with the building, and everyone agreed that there was something odd and off-putting about that mirror. Some theories suggest that mirrors are portals to other realms or that entities will make their presence known in them. While by the mirror, Bernadette and Josh heard something moving in the back room, where there is a washer and a dryer.

The active investigative night ended, and the team marveled at the amount of ghost interaction that had occurred. It had started from the beginning and went right through to the end, which is unusual on a ghost hunt. You usually have periods of calm with periods of activity, not continuous and throughout every nook and cranny of a building. Maxson House has to be one of the most haunted buildings not only in Old Forge but all of the United States of America. The team members held hands in a circle closing prayer and beamed at the wonder and glory of an interaction with the other side. These types of investigations charge

the mental batteries of the Ghost Seekers of Central New York. We are honored and privileged to be able to walk into beautiful structures and chat with the spirits.

BERNADETTE'S TAKE: I felt a great connection with Lori and this house. It's fully loaded with an orchestra of ghosts, with Lori as their conductor. Mr. 666 is not an evil presence but rather a large male spirit that likes to spoon the ladies while they sleep. The spirits enjoy this location and seem to happily coexist with Lori and her family. I would love to know the origins of Pumpkin, the little girl spirit that plays in the Maxson House, but some mysteries are never meant to be solved.

FULTON CHAIN CRAFT BREWERY AND ADK FITNESS

June 20, 2015—At one time, this building hosted Northern Lanes Bowling Alley, but now it is being renovated into having the Fulton Chain Craft Brewery up front and ADK Fitness in the back part, where the lanes had been. Back in March 1964, William C. Wark, sixty-one, died in the bowling alley when he had a heart attack. He was on the line, bowling ball in hand, ready to roll the final ball of the tenth frame in the match between D&D Food Market and Brussels Garage when he was stricken. The June investigation would make the Ghost Seekers wonder if it could be William they were meeting, or perhaps another spirit, as there would be many on a dark and rainy night among the pines and buildings of Old Forge. The team had been contacted by Lisa Murphy, owner of the building, who had the seekers investigate her other business, Tony Harper's Pizza and Clam Shack. Lisa had experienced noises from the basement and items being moved within the kitchen, including knives being picked up and placed in other areas of the kitchen. Lisa had heard glass breaking in the basement and investigated, only to see that there were no shards or broken glass anywhere.

The Ghost Seekers were represented by the investigators Bernadette, David, Dennis, Len, Josh and Helen. The teams would be lean, but the ghosts would be fat—or at least robust in their interactions with the group. One investigator always sits at ghost central and watches the feed from the night-vision cameras while investigations are happening. This is necessary because the watcher of the monitors must write down anything paranormal. Many times, spirit lights are caught moving independently and intelligently

The Fulton Chain Brewery and ADK Fitness now occupy the building that had been the Northern Lanes Bowling Alley.

It's easy for an experienced paranormal investigator to tell the difference between dust, bugs and critters and spirit lights. In the past, the ghost seekers have picked up shadow people walking back and forth in the night. The walk-through is always done to get a feel of the layout and determine placement of cameras and the possible ghost hot spots. This can increase the odds of a paranormal interaction. This is also put together with the location where owners tend to experience the paranormal. It takes a good hour to snake all the wiring, plug in all the cameras, calibrate all the equipment and formulate teams. The last thing is a prayer of protection that we use to ward off evil and embrace the good. The first team was Helen and Len, who went into the Fulton Chain Brewery; Dennis, David and Josh headed over to the ADK Fitness. Bernadette was nestled into watching the happenings at ghost central. We had been greeted by the Fulton Chain Brewery group, led by Justin, who was happy to have us there. We marveled at the beauty and hard work being done in the business. Justin and the workers left so we were alone to conduct our investigation.

Dennis, Josh and David in the fitness center under construction wondered if they would get anything since there was a large, gaping hole where the entrance was going to be. The team was told that the old wooden lanes of the bowling alley had remained, as they were under the flooring of the gym. The opening was wide enough that outside noise could easily interfere with the investigation—or a random black bear could stroll right

in, if so inclined. Dennis had found in the other building the leftover bowling balls and pins, so he had brought three pins and one bowling ball and had set them up in the middle of the unfished room that would soon host exercise equipment. The room had ladders, saws and all sorts of tools. The walls were unpainted sheetrock, and a single overhead light was on in the far corner. It gave the large room an ominous glow and a distinct edge between the dim light and the darkness.

As soon as the group walked into the room, Josh felt something all over his body. Everything on his body was standing on edge. After several minutes, the team set the flashlight among the bowling ball and pins, and right away David was getting responses to his questions. Josh felt that the spirit present liked David and was clinging to him. Both felt that the name was Sam, so it seemed it was not William, the man who had passed in the alley. Josh got a vision of an older man with white hair and white beard, about five feet, seven inches tall. Just when things got quiet, Dennis took the bowling ball and knocked down the pins. That stirred things up, and Josh got the feeling that there was another grumpier presence unhappy with us being there. The group went into a side room off the large one, and right away Josh felt this grumpy ghost smothering and on top of him. Perhaps this was William, who had passed away never having completed his game, having died with that last bowling ball not thrown. In photos, there were spirit lights hanging on to David and hovering above Josh. The group was happy to get out of the ADK Fitness business and back to ghost central with everything mortally and spiritually intact.

The other team of round one were Helen and Len, who went into the Fulton Chain Brewery, which was in the final stages of construction and only a week away from opening. Helen immediately got a bad feeling over near the bathrooms, right next to the seating area. Len and Helen sat at the bar and started an EVP session with the REM pod; Len held the night-vision video camera. It didn't take long for the spirits to come out and play. The temperature dropped when they heard a ghostly female voice echoing across the Adirondack chair barstools. It was difficult to distinguish the exact words, as there was mumbling and whispering. The temperature went back up and then down again as the ghost of the woman kept teasing the investigators. The two decided to go down into the basement, where the glass had been heard breaking by the owner. They did not see an entity, but there was at least one present, as they kept hearing footsteps in the darkness; the shy ghost stopped short of the flashlight, though. The temperature was fluctuating, and the ghosts were

responding with banging. The team left the basement and regrouped with the others at ghost central.

Round two saw Helen and Len going out to the bowling alley where ADK Fitness was going to be, and they immediately felt creepy and eerie walking into the club. Helen felt nauseated, a sign that something angry was in the vicinity. Right away, Len and Helen encountered negative energy, with footsteps all around the former bowling alley and banging with knocks thrown in. It was right after this that Len felt that he was being engulfed by activity and spirits causing him to spin around. Then an unseen, angry entity two-hand pushed Helen from behind, right on her shoulder blades. The ghost tried its best to send her to the ground, yet Helen was able to stay on her feet. This caused the seasoned and solid paranormal investigators to flee the room and return to ghost central.

Josh, Bernadette and Dennis went down to the basement. Both groups got their paranormal appetites satisfied with a ghostly banquet. Watching the night-vision camera in the basement, Dennis made the observation that the abnormal number of orbs could possibly indicate a portal. When Josh, Bernadette and Dennis got to the bottom of the basement stairs, all noted a musty smell that not had been there earlier. It quickly disappeared. Within a minute of settling down to start the EVP session, Dennis felt something crawling on his back and tingling his spine. Right after this event, there was a knock, and Bernadette saw something dark move above Josh's head. Bernadette got a feeling of sadness and felt that the spirits in the basement might be trapped but were very lonely. The group heard footsteps, and then Bernadette saw a malignant figure of a deformed shadow person all bent over. It bent down and got on all fours, and Josh wondered if it were a spirit animal. Bernadette said no—it malignant and odd. Len came down to join the group and reported that they had to cut their investigation off early in the old bowling alley, as things had gotten scary with Helen being pushed. Len's appearance amplified the events, as all of a sudden loud knocking and movement occurred, all behind Bernadette. The group wondered if Len had something follow him into the basement.

The team went upstairs into the old restaurant that now housed all the old bowling balls, pins and booths. It was packed with old dusty stuff, but that didn't stop the ghosts from coming out to play. The odd thing was that the entire group smelled a very strong odor of feces. It was overwhelmingly repugnant, and everyone had been in and out of the room many times that night and smelled nothing. Within seconds, the smell was gone. A few minutes later, there was a sneeze right behind Josh, and Bernadette's

arms became ice cold with goose bumps and hair standing up all over her arms. She held her bare arm out, and Len shined his flashlight on the flesh; the team was stunned to see the hairs standing on shocking end on Bernadette's arms.

The team walked out of the ADK Fitness and Fulton Chain Brewery convinced that the structure was haunted. Once again, Old Forge delivered a haunted locus. This made everyone marvel and wonder if every single building in the town had spirits. Perhaps it was the water. Perhaps it was the mountains. Some feel that the place is so beloved by many current and dead locals and tourists that they just can't leave the pine-laden paradise.

BERNADETTE'S TAKE: I didn't know what to expect on this investigation, but again I was in the midst of an active ghost hunt up in Old Forge. The building is in a quiet corner of the village, but don't be fooled by the charm of the fitness center or the sweet taste of the beer—this place hosts ghosts. It makes one wonder if the spirits appreciate the moral enjoyments we have on our plane of existence?

Riverview Cemetery

July 19, 2014—Close to the center of the village of Old Forge sits the Riverview Cemetery, a place where the recently passed residents of the town are laid to rest for all eternity. The cemetery is rather small, as it's only been taking on the deceased since 1921. The cemetery land had been donated by developer William Thistlethwaite. The original name was Old Forge Cemetery, but Reverend John Fitzgerald proposed renaming it St. Stephen's Cemetery in honor of the first person buried there, Stephen Bazyliv. The location is next to a small river. It's this location that is mesmerizing both in the day and the evening. It's where an extraordinary paranormal experience occurred that defied all logic. The Ghost Seekers first became aware of the cemetery after speaking with Kate Lewis, director of the Goodsell Museum, which hosts the Town of Webb Historical Association.

The group sat in the Goodsell Museum as Kate brought forth photos of the grave marker of the first person buried in the cemetery. Kate told the story of Stephen and his heroic life and tragic death. Stephen Bazyliv had been a Ukrainian citizen who was living in Syracuse when he joined the army to fight in the Great War (or World War I). He was in the Ninth Infantry, Company B, of the American Expedition Forces. Stephen fought bravely and was wounded at the Battle of Verdun. He was gassed and shell shocked. Upon his return to Syracuse, his lungs deteriorated until he was diagnosed with tuberculosis. The Red Cross sent him to a tuberculosis clinic in Old Forge, and the hero fell in love with the rugged beauty. He quickly made many friends and went on many hunting and fishing trips with his

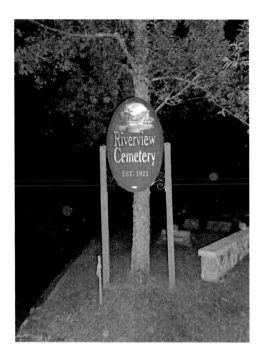

Left: Riverview Cemetery entrance with multiple orbs.

Below: The headstone of Riverview's first buried war hero Stephen Bazyliv, with creeping ectoplasm.

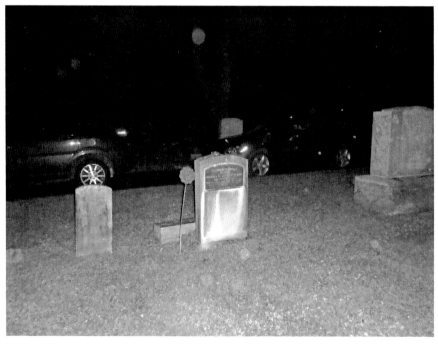

fellow veterans. One day, as Stephen returned from a hunting trip, he paused to light his cigarette. He leaned his rifle against something while he lit his smoke. The weapon fell to the ground and discharged, and he was shot in the neck. He would die of his wound, and his fellow veterans and American Legion brethren buried him in the colors of his adopted country.

The Ghost Seekers decided to pay a visit to the cemetery and especially pay tribute to Stephen. Dennis and Bernadette stopped by in the middle of a beautiful day when there were people placing flowers on the final resting place of their loved ones. As soon as they got out of the car, Bernadette felt compelled to go to the back-left corner of the cemetery. The two authors and paranormal investigators slalomed through the arranged tombstones until they came to the back corner. You could see a small river snaking past the spot. Bernadette could not explain why she was having strong feelings about that corner. The feeling passed, so they moved on their way. Weeks later, they would find the reason why that corner proved to be so compelling. The night of the Tony Harper's investigation, Dennis, Len, Ed and Irene were in Old Forge. The group had to wait until 1:30 a.m. to set up and begin since the business didn't close until that late hour. The team decided to go

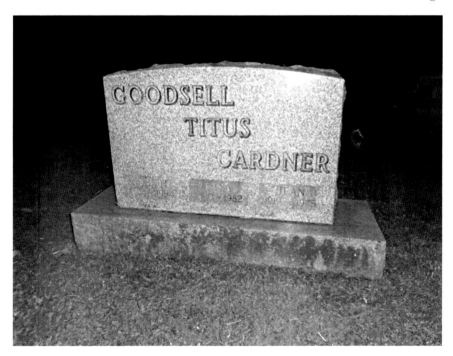

Grave marker of Robert Goodsell and Tena Goodsell Titus.

to Riverview Cemetery and walk the grounds. It was hours past dark, and clouds muffled the moonbeams, which flashed across the engravings of the names of those who had passed.

The team started out at the grave of Stephen, where they were conducting an EVP session and trying to channel the spirit of the hero. Irene is a psychic who tunes in to the dead and felt that Stephen was reaching out, claiming that he was sad. At this point, Dennis took a photo of the grave. In this picture is what appears to be ectoplasm seeping from the ground and creeping up the face of the grave marker. The team fell silent out of respect, but Irene suddenly grabbed her temples and complained of a massive headache. "I need to go over there," she said, pointing to the back-left corner of the cemetery. She was pointing to the exact spot where Bernadette had been compelled to go. Like a paranormal bloodhound, Irene was off on the scent of the ghost. Dennis, Len and Ed just followed along, not saying a word. Irene said that she was drawn to that area and didn't know why. Dennis had never told anybody that Bernadette had been drawn to the same area and kept quiet to see what was going to happen. A large flow of clouds covered the moon, but the seekers were ready with flashlights to illuminate the path through the gravestones. Irene got all the way to the back corner and then went up to a marker. Her headache went away. She asked Len to come over and shine his flashlight on the grave. When he did, the team was stunned. The grave was the final resting place of Robert Goodsell and Tena Goodsell Titus, the very same family whose beloved old home is now the location of the Goodsell Museum. The team could not get from them what message they were trying to send. The seekers guess that they want people to know, especially Kate, the director of the Goodsell Museum, that they are pleased with the use of their homestead. The feeling at the grave was of warmth and love. The team members just stood and stared at the grave marker and respectfully bowed their heads.

BERNADETTE'S TAKE: I was amazed at the pull I felt when I first walked onto the hallowed ground of the Riverview Cemetery. I was compelled to go to the back corner, and there I saw the lovely stream rolling past. Once again water was involved with a paranormal place and occurrence up in Old Forge.

Peter "Indian Drid" Waters

July 19, 2014—Next to First Lake in Old Forge sits a solitary stone with a plaque that's supposed to have been the final resting place of Indian Drid. The plaque reads, "Peter Waters Born 1809 died September 17, 1833 Rateristaiens (Law-They-Lee-Staiens). He was a hunter, trapper, guide on the early days of the Fulton Chain, a Mohawk from the Akwesasne reservation. He was killed while hunting on his ancestral land, and this is his final resting place." Peter Waters was called and known by the locals as "Indian Drid." His restless spirit hovers over the sacred waters of First Lake, where his life had been ended by the crack shot of an assassin who hid in the shoreline woods and shot Indian Drid dead while in his canoe. The person who would be tried with pulling the trigger and shooting Indian Drid was Nathanial "Nat" Foster Jr. The murder ended what had been a running feud between a legendary Indian killer and a local man of the Mohawk tribe.

Nat Foster is a legendary trapper and hunter of the Adirondacks whose exploits were written about in A.L. Byron-Curtiss's book *The Life and Adventures of Nat Foster, Trapper and Hunter of the Adirondacks*. Foster had grown up in New Hampshire, and his father was a veteran of the Revolutionary War. Nat's father was a notorious hater of Indians and had instilled in his son a distrust and hatred for them. Reinforcing this was the fact that Nat's sister had been kidnapped by a raiding party of Indians, and he had several deadly interactions with Indians that had resulted in Nat shooting them dead. Nat was a tall man who wore buckskins and a coonskin hat. He was reportedly the best at loading his musket and firing it an amazing six times per minute;

he did this by nesting lead balls between his fingers. Nat had killed a large charging bear at nine years old, had taken on mountain lions and was able to track game and Indians better than anyone in the United States at that time. Nat's descendants claimed that Natty Bumppo, or Hawkeye, the character from James Fenimore Cooper's *Leatherstocking Tales*, including the story *Last of the Mohicans*, was based on their ancestor Nat Foster.

Nat had been called "Leatherstocking" by family and friends. Nat was also called "Indian Killer" by many for his deadly encounters with them. By the time he moved to Fulton Chain, near Old Forge, Nat was sixty-nine years old and not the rugged young trapper anymore. His legend came along with him when he moved with his family into the Herreshoff Manor, the place that housed the original founders of the area. Nearby to Foster, Peter "Indian Drid" Waters lived with his wife and children. At first, the Fosters were kind to the Indians, giving them food and milk during the rough winters. But Indian Drid was young and proud. The two men got into a fight when Nat thought that Indian Drid had sunk his boat. Nat held Indian Drid at gunpoint and took him to the site of the sunken boat. When Nat let his guard down, Indian Drid pulled a knife. Although much older, Nat was able to wrestle the knife away from the young Indian. It was said that the two told each other they would not live much longer.

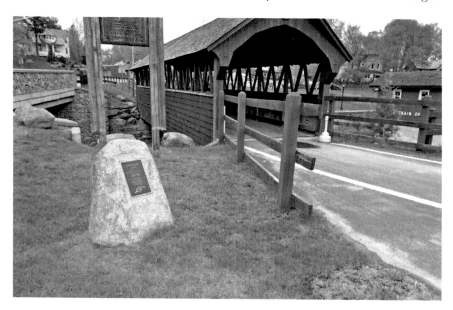

Burial spot and memorial to Peter "Indian Drid" Waters by the covered bridge.

Drid was rumored to have teased Nat about being an Indian killer.

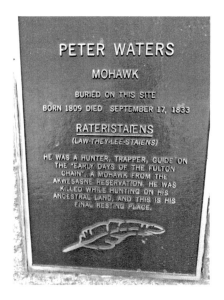

The location of the shooting was where the channel of Old Forge meets First Lake. This spot is referred to as "Indian Point" and by some as "Murder's Point." The day of the shooting, Foster interacted with and had been seen by two hermits who lived near Nat Foster. Indian Drid was in his canoe, and between him and the shore there was a boat with the two hermits in it. Nat was seen by all; he leveled his gun and fired twice, with the bullet traveling between the two hermits and tearing into the body of Indian Drid. Peter Waters slumped over dead from his wound, with his head touching the sacred water of his

Plaque on the front of the grave marker of Peter "Indian Drid" Waters.

hunting grounds. The rifle was what was called a "double shooter," and Indian Drid's body would show two entry holes. Foster was arrested and put on trial. At the time, it was difficult to get a jury to acquit a white man in the death of a "red man." The testimony included all the past threats Indian Drid had made, including him behaving badly in Lake Pleasant. Nat Foster's previous killings of Indians was never brought out during the trial. Foster was declared not guilty, to the great joy of those in the courtroom. Indian Drid would never get rest. The people of Old Forge would always remember him fondly. On October 1, 2001, the current marker of a large boulder and plaque was dedicated by town officials and representatives from Peter "Indian Drid" Waters's tribe.

The Ghost Seekers of Central New York conducted an EVP session and had brought along psychic Irene Crewell in the summer of 2014 to attempt to channel the spirit of Indian Drid. The grave site and memorial is right next to a covered bridge and a loud spillway, so detecting any whisperings from the other side could not be recorded. The group members bowed their heads in respect and asked Indian Drid to be at peace. At the next investigation at the Old Forge Hardware Store, the group felt the presence of Indian Drid. The store sits up on a hill that is right up from First Lake. The seekers received positive responses during question and answer

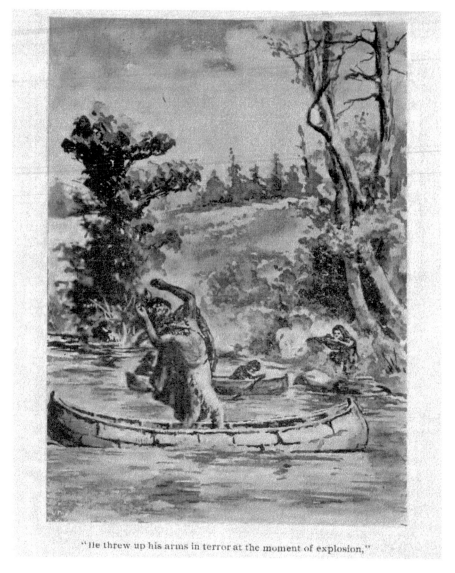

"He threw up his arms in terror at the moment of explosion,"

Artist's rendering of Nat Foster shooting Indian Drid.

session and felt his presence. Irene had felt that he was sad and restless. He had died young and tragically, leaving behind his family.

On another night, Dennis and Paranormal Ed were in Old Forge to do an investigation of Tony Harper's Clam Shack. Len and Irene were there as well but were up at the pub talking logistics when Dennis and Ed decided

to go down to the grave and water's edge at midnight. It was a pitch-black and cool summer night with no sound except the spillway. Dennis and Ed walked along the edge of the shoreline speaking to the ghost of Indian Drid. Dennis had his digital camera and took several pictures of the still lake. Ed then said, "It would be great, Indian Drid, if you could show yourself." At this point, a large glowing round spirit light appeared on the water. Dennis took a snapshot, and it came out on the digital camera. The photo looks like a black mass with a bright light in the middle. Paranormal investigator Len had been the stop at the Indian Drid grave site on the haunted walking tour of Old Forge for the past two years. The Ghost Seekers had done this tour as a fundraiser for the Goodsell Museum. At his stop on the tour, Len would talk to the groups about the life and tragic death of Indian Drid and then play a marvelous and emotional tune on his wooden Indian flute.

LEN'S TAKE ON INDIAN DRID: The sun had long set, and I was waiting for my first group. The mercury streetlamp was on its way to full illumination. There was a mist in the air, and I had to cover the table that held my Native American spirit flute. I spied my first group approaching. They stood wide eyed anticipating a tale of intrigue. All were glued to the tale of Indian Drid and Nathaniel Foster. With each group, I noticed nodding heads, as if validating that I had done my homework. With each group, there seemed to be something different. With the second group, as I was talking about the spirit light photo on the water, a bright light appeared on the pond. This startled me and the group. We all had a good chuckle as we realized that it was the bow light on a boat. A few people in the group noted the perfect timing. Also with the second group, as I played some ethereal notes on my flute, a loon answered the tones. When the fourth group was listening to the flute, again the loon on the pond responded. My last group was a solitary soul. She was so attentive. It was a pleasure to be one on one imparting the story of Indian Drid and Nat Foster—an experience that was worth the effort. I feel the flute connected me and the curious to Indian Drid's soul.

There's no doubt that the spirit of Peter "Indian Drid" Waters remains near First Lake. The Ghost Seekers feel that he is the epicenter of all the hauntings in the town and might even be the guardian of the portal to the other side. In researching the Indian Drid assassination, Bernadette and Dennis discovered a tragic drowning that happened on August 28, 1944, at the exact spot where Indian Drid had died. In the channel between Old Forge and First Lake, Myrne Moose drowned. He had been riding in a canoe

Nestled between Second and Third Lakes is the legendary Witch Tree, a center of spooky stories. *Courtesy Town of Webb Historical Association.*

with his seven-year-old son, Richard, when they flipped over. Two teenagers were nearby and heard the cries for help. They had to row over, and what they saw was Myrne holding his son above water. The teenagers were able to pull in Richard, but it was too late for Myrne, who had slipped under the water and passed away. Could the spot be an evil spot? No matter the opinions, the spot is a place to be respectful of the dead. Myrne's body was discovered the next day by none other than Robert Goodsell, whose home now hosts the Goodsell Museum.

Traveling down the Fulton Chain of Lakes, you'll go from First Lake deeper into the woods and water until you reach the channel between Second and Third Lake. There you'll see remnants of a stump sticking out of the water; at one time, it was taller, with an insidious shape of a hag. The "Witch Tree" had long been alluring to those scared of the dark nighttime waters of the chain of lakes. Many campfire tales have speculated on the origins and reasons for her wooded appearance. Could it be possible that the old hag had appeared to lead lost spirits from the portal of the afterlife to the waters of our mortal plane?

BERNADETTE'S TAKE: Praying by the burial site of Indian Drid was something my group of Ghost Seekers and I felt compelled to do. It's sad to know that the young man was assassinated, and I wonder if his spirit will ever be at peace. Old Forge is home to him and his ancestors, and his restless spirit will keep appearing above the still waters.

FOREST HOUSE (HERRON REALTY)

AUGUST 2014—The Forest House is a quaint, beautiful building packed in among a row of structures down the main thoroughfare of Old Forge, but the white building with the dark-green shutters is anything but common. It currently hosts Herron Realty, where many land transactions occur, but the beautiful building had at one time hosted people afflicted with tuberculosis. Back in the early twentieth century, the Adirondacks had been considered an ideal place for those suffering with tuberculosis (or what was referred to as consumption). Most cottages and hotels would advertise that those inflicted with the debilitating, contagious and deathly disease were not welcome, but not the Forest House. It would take in the traveling sick looking for a miracle cure. The Forest House hosted the first town doctors in the early twentieth century when Dr. Robert S. Lindsay and Dr. Stuart W. Nelson practiced medicine out of their offices in the building. They would eventually purchase homes near the Forest House.

Dr. Nelson suffered from tuberculosis, as did Ella Lindsay, the wife of Dr. Lindsay. This would set the stage for the tuberculosis sufferers to come to Old Forge to have their disease improve under the pines and frosty air of the north country. The Forest House would have tuberculosis patients sitting right on the front porch, with locals staying away for fear of the catchable and fatal affliction. Mary Doolen came to operate the Forest House and, in 1916, hosted two of the most famous guests in the history of Old Forge: two young nonrelated girls who looked so much alike that the residents of Old Forge referred to them as the "Twins." The young girls were only four years

old, and their fathers were both staying at the Forest House to try to get relief from the pain of their tuberculosis. Mary Doolen was from Ireland, and her Catholic faith pushed her to help others. The young girls were both named Helen. Helen Witzenberger and Helen Corey would have a festive Christmas that year due to the kindness of Mary and the townspeople. For one day, God smiled on the Forest House and had rays of hope pierce the tragedy, sadness and death. There would be many more patients in the Forest House, but today the building houses a very successful real estate business. Yet the ghosts of the past still seep from the walls and creep from the attic. It would be the locals who would speak of the entity that lingers up on the second floor, walking the floors at all hours of the day and night. If you face the building from the main street, the Forest House entity is on the second floor to the far left.

The scariest story of the Forest House came when the Ghost Seekers of Central New York were conducting a session on Old Forge in the pole barn at the Goodsell Museum in the summer of 2014. It was only a few days before the seekers would be conducting the haunted history ghost walk of the buildings in the village. Dennis was talking about the investigations when

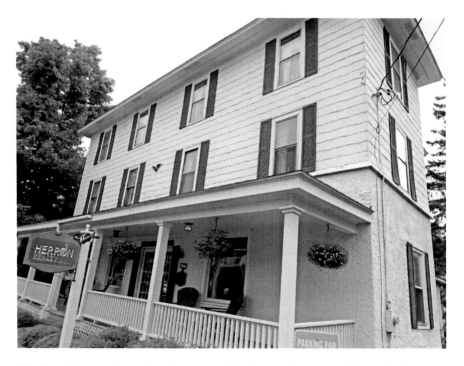

The Forest House, where tuberculosis patients had stayed. It now hosts Herron Realty.

a person in the back asked about the Forest House and the ghosts of the tuberculosis patients. The Ghost Seekers would not be granted access to conduct an investigation, but a psychic working with the team was able to go on the front porch and became overwhelmed at the sadness and sheer number of lost souls hanging in the Forest House. The audience was a mix of tourists and locals, but all knew the house that was being discussed, as it's a beautiful bright-white building with dark-green shutters and the Herron Realty sign out front. It had become a place of happiness, as people would now be in the building fulfilling their dreams of property ownership.

After the "Haunted Old Forge" presentation was all over with, all the attendees filtered out except one small old lady. Dennis noticed her standing in the back clutching her purse with a fearful look in her eye. He went over and asked if he could help her, and she said she wanted to talk but not until everyone was gone. The staff of the Goodsell heard this and excused themselves. Dennis pulled up a chair, and the sweet elderly woman, who was nowhere near five feet tall, sat down. She looked at the floor as she spoke. "I have to tell you something about the Forest House," she said. Dennis answered with, "It's going to be ok. I'm listening." The lady, who never gave her name, lifted her chin and said that the place was haunted. She had sworn to her husband that she would never tell anybody what they had seen many years ago. The couple had stayed upstairs in the Forest House many decades earlier. They woke to a moaning that was coming from the bathroom. They were frightened but proceeded to the door, beyond which they could hear the moans echoing. Her husband pushed open the door, and standing there was a ghost of a man with a bloody face. He looked at them and moaned while clutching at his shaking body. The lady told Dennis that she had never believed in ghosts, yet she and her husband were religious. She said she was frightened at first, but then they felt sad for the agonizing man, whose see-through shape drifted off and disappeared. "What do you think this meant?" she asked Dennis as she shook. "He needs to be sent on his way," said Dennis. "Or perhaps when he vanished he had moved on as his business on this plane was finished." The lady smiled and said, "That's what we thought. You'd think we'd been scared, but we were afraid for his soul."

Back in the summer of 2014, the Ghost Seekers of Central New York conducted a historical ghost walk of Old Forge. Irene Crewell, psychic and former member, had been positioned on the front porch of the Forest House. The group had done a walk-through of the tour a week ahead of time, and Irene's psychic abilities picked up a tremendous amount of sadness associated with the building. When she got up on the porch, she felt drained and then

became short of breath. She had not been told that the place had housed tuberculosis patients, as Irene likes to work cold when working on a case. Irene could not fill up her lungs with air and was gasping. At this point, she witnessed a female ghost, or what she called an apparition, cloaked in white and not quite see-through but transparent. She was looking at Irene from inside the Forest House. Irene was told afterward about the historical past of people living in the Forest House with tuberculosis, and it all made sense to her. She felt that the dread she experienced was from the patients who had died there. Irene is also one of the rare psychics called an "empath," so the ghosts of the former sufferers were flocking to her. She said that the night of the ghost walk, it was hard for her to stand on the porch of the Forest House, as she had to shield her own spirit from the many who had died and wanted to come to her. Even during the ghost walk, with throngs of tourists, Irene witnessed ghosts coming and going. The next time you drive through Old Forge, pause at the Forest House and say a prayer for the souls of those who suffered under the disease of tuberculosis. Perhaps there are other souls trapped waiting to reveal themselves and move on to a better place, where suffering ends and happiness reigns forever.

BERNADETTE'S TAKE: The Forest House is a sad place that at one time did harbor love. The caretakers wanted to ease the suffering of those with a horrendous affliction. Those who passed inside the Forest House from tuberculosis may not even know they are trapped among the living. I pray they find the light and move on to peace in another dimension.

THE HOLLYWOOD ROAD
BOATHOUSE

August 15, 2015—Just past the Water Safari park in Old Forge, on your right, is Hollywood Road. It a charming, winding road that snakes along the edge of First Lake. It's lined with camps for seasonal residents and homes for the year-round residents. The rustic waterfront area has deer and black bear walking among the structures, but something else walks the night and has the residents in awe: the spirit of the lady of the boathouse. Ghost Seeker and paranormal investigator Joe Ostrander came to the group with a haunted legend told to him by his friend Rick Suprenant about the boathouse on First Lake and the lady walking the driveways and the road in proximity to the rundown structure. On a sunny and warm afternoon, the Ghost Seekers of Central New York met Rick and his wife, Tammy, by the visitors' center in the heart of Old Forge. We stood and listened to Rick tell us of the ghostly walking of the lady of the boathouse. Old Forge is one of the few remaining places in America where GPS gets discombobulated and cellphone signals are single-bar sparseness. Before contacting the Ghost Seekers, Rick and Tammy had a psychic come to the area and noted that she had felt the presence of a female soul trapped wandering the path from the house to the shore.

We had to follow Rick and Tammy to the location, as it is not available to find on our modern devices. About a mile down Hollywood Road, on your right, is the boathouse. It's a small wooden structure that leans a little with faded red paint. The gray crumbling wood peers out from beneath its peeling paint. The waves of First Lake were lapping up against the shore where the little boathouse rested.

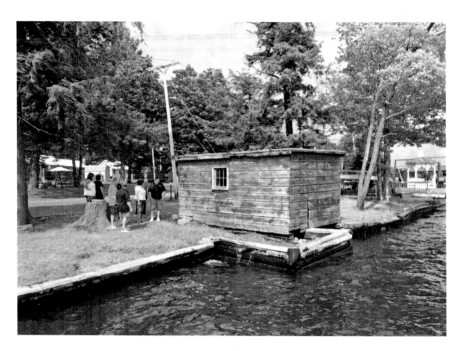

Haunted boathouse on Hollywood Road.

The entity of Jennie Boyce has been seen walking this driveway on Hollywood Road.

The memorial stone of Jennie Boyce adjacent to the haunted boathouse. *Courtesy Rick Surprenant.*

The Ghost Seekers on site included David, Bernadette, Len, Dennis, Joe, Helen and former seeker back on the trip, Carol. Judi was there as our psychic advisor. The vehicles were parked right off the road, and summer revelers were sitting on their decks and front porches watching the odd collection of people in their black polo shirts with the Ghost Seeker logos proudly embroidered on the chest. Rick and Tammy started telling us of the spirit of Jennie Boyce, who had lived up on the hill above the lakefront homes. The locals had repeatedly seen her spirit walking the path from her old estate on the hill to the water next to her boathouse. This route takes her down a gravel driveway that splits two camps. When we got close to the boathouse, we saw something odd—something you never see sitting adjacent to any structure, let alone a building that protects water vessels from the exterior elements. We looked at it closely, and there was no mistake: it was a grave marker. On the small square gray slab is the engraving, "Jennie Boyce 1883–1917." The time of her death was a different time in Old Forge. This was when only a handful of brave and tough individuals lived among the harsh Adirondack conditions. This was way before tourists and waterslides, when logging and hands-on living were the norm. It was not the place for the weak of body or spirit. There's no doubt that Jennie had to have been ⌐ ⌐ ⌐ ⌐ ⌐ ⌐ ⌐ ⌐

up in the early twentieth-century Old Forge. The group theorized that the marker had to have been a family tribute to her most favorite place and not a marker six feet above her long-buried bones. It was a strange yet moving tribute. As we stood next to the boathouse and looked down First Lake, we realized that Indian Point was not far away. This was the location of the assassination of Indian Drid. The water and area was hallowed and sacred. Death and love attracted the spirits.

Next to the boathouse was the stump of a tree. Rick explained that the lot on which the boathouse sat was small, with he and Tammy owning the property to the left and another family owning the property to the right. Few people had ever seen the true current owner of that small sliver of lakefront property where the boathouse rests. The only people who knew any details of the ghost and the road were Joe, Dennis and Bernadette, and all they knew was that there was a ghost being seen walking on the road by the lake. There was no way to try to conduct Internet research about Jennie Boyce. The group tries to keep psychics like Judi in the dark about details going into a haunted location. On this trip, they had not told Josh or Helen a thing. They do not claim to be psychic, but they have paranormal vision when it comes to the spirits. As we drove down Hollywood Road, Helen closed her eyes, placed her hand on her forehead and said that she was seeing a boathouse with a grave marker and a stump right next to it. Rick and Tammy never once mentioned any of these details, and this haunting had never been written about or even featured in the local lore.

When we pulled up and stopped at the boathouse, Helen got a massive headache and could barely get out of the car. She stood back as the others approached the site and refused to go closer. Dennis asked Josh, and he said he wasn't feeling anything. The ability to see the dead is not something you can turn on and off like a light switch, and Josh just wasn't tuning into the paranormal frequency. Judi, on the other hand, had been drawn to the gravel driveway and not to the boathouse. She felt something different there—something sad, domineering and depressing, but not the spirit of Jennie; she felt that a male entity was wandering back and forth. It was at this point that Rick and Tammy said that the house nearby had at one time been a home to several people with mental disabilities, and they had a man who would do nothing but walk up and down the driveway all day long.

The Ghost Seekers took turns looking through the cracked and stained window into the boathouse and were able to see a few small boats covered with decades of dust and cobwebs. At this point, Helen had decided to come closer and look over the boathouse. She crept closer to the structure, and

even though it was a warm and sunny summer day in the Adirondacks, she felt a wave of darkness come over her entire body. She stopped and was stunned to see the grave marker and the stump next to the boathouse. Carol had to hold her arm and keep her steady. The ladies decided to get right up to the boathouse and look in the window. Helen could see something she described as "pure evil" and "horrifying" inside the boathouse and had to flee the area. She felt afraid and said that the area had a depressing and anxious feel to it, as if many depressed souls were clinging to the boathouse. The team members all piled into their vehicles and drove off happy to leave the boathouse in the rear-view mirror. Perhaps someday somebody will meet the ghost of Jennie Boyce on her trek to the lake and ask her why she remains compelled to repeat her nightly journey. She might just answer.

BERNADETTE'S TAKE: When we arrived at the boathouse, I could sense the pull of the spirits to the water. I can see why ghosts would come to the water's edge under the moonbeams during the witching hour. The lake is alluring, and I can see why the ghost of Jennie Boyce would make a nightly visit.

MOOSE HEAD HOTEL
(TRUE VALUE HARDWARE)

J.UNE 2014—When you drive down the main drag of Old Forge, you will see a True Value Hardware store sign affixed to a building that at one time hosted the traveling elite of the United States when it was the Moose Head Hotel. The original hotel was built by Samuel A. Smith in 1908 and attracted many with its fantastic location on Main Street. The Moose Head Hotel was considered a favorite place to stay by local teachers. The original hotel was destroyed by a fire, and a new hotel was built by Samuel's wife, Eliza Helmer, who named it the New Moose Head Hotel. The Ghost Seekers were fortunate to have been brought through on a tour of the building back when it was unoccupied with a personal escort of a town resident. The few members who walked through the place felt extremely uneasy at the paranormal burst of activity that was happening in the middle of a sunny summer day. Many people ask why ghost hunts are at night. This is because the cameras have night vision, and it seems entities are picked up better during the midnight hour. Hauntings can occur during the day, so it was not unusual that there was spirits active in the Moose Head Hotel/True Value building. Josh, who is psychic and visionary with the spirits, had an intense headache as soon as he stepped into the building. He had visions of spirits and tragedy and could see with his third eye tragedy and fire. The amazing thing is that Josh received this vision before anybody on the Ghost Seekers team knew of the past fire. There was no doubt that the place was haunted, and the seekers were getting a reaction just walking through in the middle of the day.

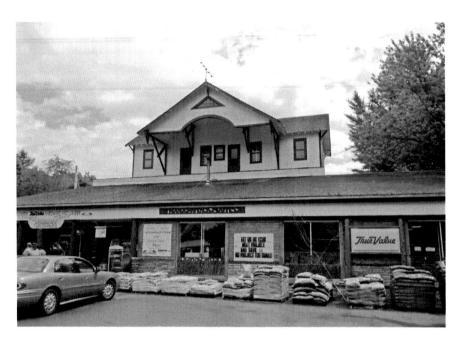

The True Value Hardware at one time hosted travelers and Old Forge teachers as the Moose Head Hotel.

Bernadette and Dennis were in Old Forge conducting a ghost reveal with a local business when a woman spoke to them about the Moose Head Hotel/True Value, as well as her and her family's haunted experiences while living in one of the apartments. Out of fear, this lady asked that we not use her name, so we'll call her "Mary." This was a difficult story for Mary to tell, so we sat down at a table in a quiet corner of a local establishment so she could talk in private. Mary said that her entire family was scared and terrorized by seen and unseen entities in the apartment. Her teenage daughter was a happy-go-lucky girl but dropped into a severe depression that Mary feels was brought on by a dark presence in the True Value building. One day, her daughter was very scared and upset, as she told Mary that she had seen a ghost of a man sitting on their couch. He was silent, did not move and just stared at her with his cold, dead gaze. Other members of Mary's family had seen ghosts of another man and woman standing in the laundry room. Mary's daughter fell deeper into depression, hid herself in her bedroom and refused to come out. Something had reached into the body of the teenager and turned her from an A student to a young woman barely able to attend

and pass school. Mary had a cousin come into the apartment and sage it to rid the spirits. The Ghost Seekers could tell you that it can work, as does sprinkling holy water or having a priest bless the place. But it is not foolproof, and sometimes spirits will remain. The burning of sage did not work, so Mary had to take her family and flee. She said that her daughter recovered from the haunting but to this day is not the same innocent and sweet teenage girl. Mary had discovered after leaving that the Moose Head at one time had a market, and the butcher lived in the haunted apartment. She had heard and told Bernadette and Dennis that this butcher had killed himself in the apartment.

BERNADETTE'S TAKE: I had an eerie feeling when I walked through the old Moose Head Hotel with members of the Ghost Seekers. Josh's paranormal radar was going off, and I could smell smoke and felt a heaviness all over my body. There is something sad and lonely in the place and perhaps ready to finish business and move into the light.

THE HAUNTED HOUSE
OF GILBERT STREET

OCTOBER 20, 2015—On a cold fall day, a reporter from the *Adirondack Express* contacted Bernadette and Dennis to inform them of a haunted house she had lived in on Gilbert Street in Old Forge. Brittany Grow is a reporter who has lived her life in Old Forge and spent a part of her life in a real haunted house. If you drove down Gilbert Street in Old Forge, you would not be able to pick out which house is haunted. The ghost-filled abode has the typical look of a warm and sweet place to sleep at night; however, looks can be deceiving. The first time the Ghost Seekers of Central New York met Kate Lewis from the Goodsell Museum, she pointed to the house next door and said that it was highly haunted. Interestingly enough, it's only one hundred feet away from the Goodsell Museum pole barn, where investigators spotted a shadow person moving.

Bernadette and Dennis drove up on a cold and wet Tuesday to meet Brittany and look over her haunted house—the one that had terrorized her and her family many years earlier. We stood on the edge of the property and listened as Brittany pointed to key areas and explained what had happened. The Ghost Seekers are a reputable group and would never step on property or go into any structure without permission. The haunted house on Gilbert Street is empty during the winter, as the owners are from out of state. In a touristy place like Old Forge, this likely makes the ghosts feel lonely all winter long. But Brittany and her family had lived in the house year round. There had long been stories of haunted experiences, including a former guidance counselor at the Town of Webb Public School who had lived alone in the

house. She had commented to several people that she had to sleep on the couch on the first floor with the lights on and the television running. She could no longer sleep and barely went up to the second floor because she'd been constantly harassed by the ghost of a man who would stroke her hair at night and stand right next to her bed. Nothing suggested that this was anything other than a curious entity; however, if you are sound asleep during the witching hour in ink-black night and wake up to a ghost staring at you, you'd be frightened. One family who had stayed at the house said that once they had a child, they started to hear a loving grandmother singing, but nobody else was there. One former male tenant told Brittany that they were in the house all alone and would be downstairs, yet he would hear doors opening and closing. He had no idea of the past hauntings in the house until he had moved out.

Brittany was a young girl when her family lived at the Haunted House on Gilbert Street, but she remembered every spooky detail as if it had happened today. Her family was building a home in Thendara while they stayed at the paranormal home. She had an old-fashioned desk in her bedroom. The desk was the type where you would fold up the writing surface and lock it. She would always keep the desk locked when not working to keep her sisters from seeing or touching her stuff. One day, Brittany was sitting on the bed

The Haunted House of Gilbert Street. *Courtesy of Brittany Grow.*

doing homework when she heard a noise. She looked over to the desk, which had been locked, yet the writing surface was being lowered very slowly from an invisible hand until it stopped. She ran out of the room frightened and didn't return for an hour, but when she did, there was a piece of paper on the writing surface as if something or someone had been sitting there working. The second-floor porch would have cold spots even on a sunny and warm day, and the bathroom door was always opening on its own. It was emotional for Brittany to stand and point to a place where she had fond youthful memories but also incidents of darkness and fright. All in a house that would fit in on any street on any town in the United States.

BERNADETTE'S TAKE: My first impression of the house on Gilbert Street was that it looked and felt like a witch's house. I could picture in my third eye an elderly couple of ladies living there with their black cats, cackling over a bubbling cauldron. I can see that these little old ladies were up to no good. The house is a mask that covers the paranormal surprise inside.

OTHER HISTORIC HAUNTS NEAR THE ADIRONDACK BLUE LINE

The following ghost investigations did not happen in Old Forge but rather very close to and within or in proximity to the blue line of the Adirondack Mountains.

VAN AUKEN'S INNE

MAY 16, 2015—The town of Thendara is right next to Old Forge and at one time had been the local hub of business. The original name of the town was Fulton Chain. The area first started to develop because of the sawmill and the train that ran right through the heart of Fulton Chain. It was right next to the Fulton Chain Railroad Station that a large hotel was built in 1894 by Cornelius Mack and named Mack's Hotel. This would be the place where many of the lumberjacks would stay while working long hours cutting, stacking and moving logs and wood—a very dangerous but necessary occupation in a growing country. It was in Mack's Hotel where the hearty Adirondack spirit was alive and still roams to this day. In 1895, the hotel was sold to John J. Wakely, who renamed it the Wakely Hotel. He would not own it long, as the Tennis brothers bought it and moved it seventy-five feet away from the tracks in 1904. The theory given was that the proximity to the tracks caused an increased risk of fire, as the smoke emitted from the Adirondack Railroad engine could throw sparks onto the wood structure and cause flames to ensue.

Eventually, the three-story hotel would be renamed the Van Auken's Inne. The Victorian structure has entertained visitors to the Adirondacks for many decades. The hotel had long been rumored to be haunted and is always on the list of places the Ghost Seekers had wanted to investigate. We called and spoke with Vicky Beck, manager of the Van Auken, and she was pleased to tell us that the owners would let us investigate. We were thrilled, as other ghost groups had been to the hotel but had only gained access to the hotel rooms on the second and third floors. We had been given permission to go into the cellar, where there had been a speakeasy during Prohibition, and the root cellar. Both areas would prove to be paranormal hot spots.

The night of the investigation was May 16, 2015, a sunny and crisp spring day. The bar was open, but the rest of the hotel was closed. Ghost hunting is always best when you have a sterile human environment. That means no outside noise, no interference from people, yet we had to work with what was going on. Little did we know at the time that the music and fun in the bar would stir up the spirits and bring them forth. Our team consisted of most of our group and our psychic advisor Judi Cusworth. While the gear was being set up, a few went along with Vicky as she pointed out the places where the hauntings had been happening. Vicky was very bubbly and sweet

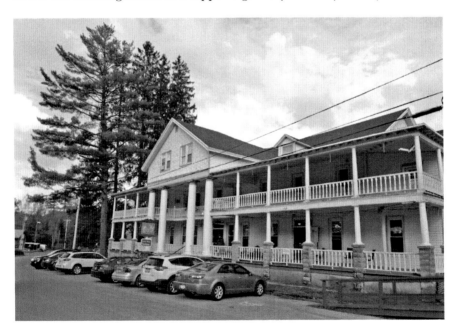

The modern look of the Van Auken's Inne.

and thrilled to have us there. Her husband, Mike, greeted us with a warm handshake and a smile. We then met the owners, Suzan and Jim Moore. The team chuckled, as we had seen Jim a few hours earlier when in town eating wings in front of Tony Harper's. Jim had come by on his loud motorcycle that had blasted our ears. We were pleased to meet the owners, and Jim decided to come along on the tour of the speakeasy in the basement.

We went down into the basement, where Vicky said it had been a storage area for beer and liquor. Jim explained that it was being renovated into the speakeasy that had operated when alcohol was illegal in the United States. They had even discovered the old secret entrance that was under the front porch. The soon-to-be basement pub was under construction, so tools and wood were everywhere. Vicky had said that when she was down there alone, a spirit of a woman said, "Hello" in her ear. On the first floor, it had been reported that a Santa Claus decoration with a motion detector kept going off for no reason, and other items were moving, causing a bartender to flee and never come back. They also had radios turn on and off all by themselves. Many had reported seeing the spirit of a man in a white coat that they called Charlie. There is a very old photo of the building back from the early twentieth century. It shows a row of people standing in front, and all can be made out except the man in white on the end. Everyone claims that was Charlie when he was alive. We said goodbye to Jim, who had to go and play his guitar in the bar portion of the hotel. He was very friendly and full of life. Vicky took us up to the second floor, where most of the hotel rooms are located, and took us to room 12. It was in this room that Vicky had been sleeping and woke in the night to feel herself paralyzed and choked. It frightened her to where she said she will never sleep in that room again. We went down the hall and stopped at rooms 8 and 9, where we were told many paranormal events had happened. Next to the rooms is a stairwell that leads right into the kitchen. A previous owner had told everyone that they had encountered a ghost on the stairs. There was no doubt that the place was haunted, and we needed to get the proof.

Ghost central was placed in the first-floor dining room. We slid a few tables together and set up our large flat-screen, giving us a night-vision video view of all the haunted hot spots. A few of the bar patrons came in to see the setup and marveled at our ghost hunting gear. We thanked them and moved them along. It was now dark outside, so we clasped hands in our prayer circle and prayed for the good spirits to come forward. Mike and Vicky joined in, as we were going to let them watch and come along. The teams would be split into two, with Bernadette, Josh, and Dennis going

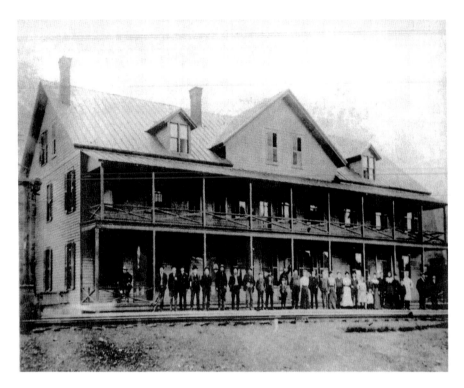

The ghost of Charlie is seen in old photo of the Van Auken's Inne. His spirit is all white to the far right. *Courtesy Van Auken's Inne.*

into the cellar and the speakeasy and Dave, Joe, Ed, Mike and Judi heading upstairs to look at the guest rooms.

Bernadette, Josh and Dennis went downstairs and right away encountered paranormal activity. Josh was near the bar for the speakeasy when he got a massive headache. Dennis took a photo, and there was a spirit light drifting above his head. Within a minute after this, Bernadette witnessed a shadow person walk past the basement window. It was strolling among the construction tools. Josh heard voices and was compelled to go back around the backside of the furnace, where there were decorations and other items stored. They set down their digital recorder, gauss meter and a small flashlight on an old toolbox and settled down to speak to the dead. The flashlight was shut off, and everything was pitch dark. Josh got the feeling of a female spirit hanging back and watching. Bernadette felt her presence as well, and they both felt it was a woman who had been a nun but had come to the hotel back in the lumberjack days to partake in unsavory activities with the working men. When they asked her name, the

flashlight lit up. They got the name Sarah. It was at this point that Dennis had the smell of fresh-cut wood, like from a sawmill. Then a large spirit light appeared near Josh and Bernadette.

After a while, the group moved over to the root cellar, where there were wooden barrels and other items stored. There was also a small wood and wire cage that was used to store dry goods from a century ago. Josh revealed that on the walk-through he had seen the ghost of a little boy in red running around in the root cellar. The flashlight was placed on the barrel, and Josh started asking if it was the little boy. Was he there? Dennis saw something move out of the corner of his eye. Bernadette had an odd feeling in there, like the boy had worked down there long ago and his spirit was now trapped. Her and Josh felt his name was Matthew, and when they called out to him, the flashlight lit up, a large orb appeared on Josh's chest and the gauss meter lit up. The group asked him to come closer, to not to be afraid, as they were friends. At this point, Dennis felt something brush up against him, all the hairs on his body stood up and ripples of goose bumps waved over his arms. He took a quick digital picture, and the outline of a shadow figure was there. It's the shape and height of a boy.

Root cellar at Van Auken's Inne, with the shadow figure of a boy entity who resides in that location. Bernadette and Josh had asked the ghostly lad to come closer.

After a quick break, the teams decided to go on round two of the investigation, with Dennis, Josh and Bernadette heading up to the second floor to go through the haunted rooms. It was dark and late, but the live music in the bar could be heard up in the rooms. The Ghost Seekers felt as if the laughter and live music brought the ghosts from their nooks to watch and enjoy the great times of living beings. The group went into room 12, where Vicky had been scared by her paranormal experiences. The room didn't have much to offer, so they moved down to room 8, where things became heavy and dark. As soon as the group walked in, spirit light began to swim around the stale air, and Bernadette and Josh both felt the presence of a man who had committed suicide in the room. Josh and Dennis stayed where the bed was, while Bernadette felt compelled to go alone into the bathroom. That is where she felt the suicide had occurred. She felt every hair on her body electrify when she sat on the tub. The team started to call this the "suicide room." The group felt that it was Charlie, as they got positive responses. Charlie put forth the vibe that he had died tragically due to infidelity by his wife, but he felt comfortable at the Van Auken so he would continue to haunt the hotel. The group moved to the third floor, where previously Josh and Bernadette felt a pulling feeling by the fire escape. The room adjacent was quaint, and right away there came around a group of spirits that communicated to the team. There were a few children spirits in there, but not Matthew. They were curious and lit up the flashlight and the gauss meter upon questioning.

The team of Helen, Ed, Len, Joe, Judi and guest Mike went down into the basement, where the speakeasy was being constructed, and had very strong similar paranormal experiences that mirrored the previous team's. Helen felt the presence of a boy entity and made physical contact when he brushed up against her leg. The group felt cold chills from the presence of what they felt was a religious entity. The interesting thing was that this religious ghost was afraid of the other entities in the Van Auken. The team was able to verify many of these experiences with the flashlight. It used a small maglight, with the spirit energy of the ghosts turning on the beam. If done right, this method can yield positive answers and interactions with ghosts unable to communicate in any other manner.

There is no doubt that the Van Auken is a haunted hotel that hosts friendly but tragic ghosts. Just don't stay in rooms 8, 9 or 12 unless you are sturdy of spirit and strong of heart.

This particular investigation turned out to confirm what Judi felt and saw with her psychic abilities. When she arrived, Judi saw an entity of a

lady in period clothing on the patio off the second floor of the hotel. She had dark hair and a flowing gown. The female ghost gave off the feeling of poise and dignity. Judi saw a young boy entity of about seven years old in the bathroom next to the bar. Her description was similar to the boy ghost that Josh witnessed in the basement. She felt the boy was shy yet observant. These were his otherworldly mannerisms when he was in the basement, and he would only come closer to the investigators with gentle coaxing. Up on the second floor of the hotel, Judi witnessed with her psychic ability a head maid moving from room to room keeping a watchful eye on guests. She gave Judi the feeling she is not happy with all the construction going on at the Van Auken. This is a common theme in hauntings. Many times construction within older mansions and homes stirs up the ghosts. Judi did see Charlie walking the second floor of the hotel, verifying the accounts of the staff and the other Ghost Seekers. These entities all came across as positive, except one negative male ghost that came right up to her nose down in the speakeasy area.

BERNADETTE'S TAKE: The suicide room was frightening but at the same time attractive. While most would run from thoughts and visions of a man killing himself in room 8, it attracted me. I don't know why I went into that bathroom and sat where it had happened. Perhaps I wanted to ease the suffering of a ghost ready to have his fate known and be told all is all right. Could it be Charlie? I think so.

THE LADY OF THE LAKE

JULY 1906—In the hot summer, down the road from Old Forge, a dastardly crime in the early twentieth century left behind one of the most famous ghost stories in the United States. Big Moose Lake is the spot where nineteen-year-old Grace Brown was tragically murdered at the hands of her lover, Chester Gillette. The man would fry in the electric chair for his crime, but Grace's ghost would become the "Lady of the Lake." The crime created a national firestorm with a best-selling novel, *An American Tragedy*, and an award-winning movie, *A Place in the Sun*. More than one hundred years removed from the crime, there are still many who have witnessed the ghost of Grace Brown floating above the tragic waters.

Chester Gillette was a young man from wealth and privilege who was handsome and traveled the country before settling for a job in his uncle's

Left: Chester Gillette would fry in the electric chair for murdering Grace Brown. *Courtesy Herkimer County Historical Society.*

Right: Grace Brown, who was murdered and drowned on Big Moose Lake. *Courtesy Herkimer County Historical Society.*

skirt-making factory in Cortland, New York. The lad also chased the skirts of all the young ladies, and the beautiful farmer's daughter, Grace Brown, caught his attention. Grace had been born on March 20, 1886, on the family farm in South Otselic, New York. She'd grow to five-foot-two and weigh one hundred pounds, yet she was confident in the city, working at the Gillette Skirt Factory. Chester charmed her, and Grace fell head over heels in love. She became pregnant, and Chester showed his love by booking a trip to the Adirondack Mountains. Their journey would see the young couple stopping at Big Moose Lake, where they stayed at the Glenmore Hotel. The locals thought it odd that the young couple barely had any luggage and the young man was carrying a tennis racquet. Chester rented a boat and took Grace out for a nice row across the dark, still water. He used his tennis racquet to beat Grace on the head and then dumped her body in the lake. Chester rowed ashore and fled. He ended up at the Arrowhead Hotel on Fourth Lake, where he got a haircut and spent the evening flirting with young ladies. Grace was found floating in Big Moose Lake, and Chester was arrested for her murder. The tennis racquet was found in the woods next to the lake hidden under a fallen pine. It would become the trial of the century, with Chester found guilty and sentenced to die in the electric chair. His good

looks and charm caused many female admirers to send him photos, which he plastered around his jail cell at the Herkimer County Jail. The Casanova had shocked a nation by murdering the pregnant and innocent Grace Brown. To this day, it is one of the most tragic criminal cases in America.

Grace's ghost floating over the water of Big Moose Lake was featured on the television show *Unsolved Mysteries* and has been in many ghost books both locally and nationally printed. Many guests of the area claimed to have seen her apparition floating over the lake.

On the 100th anniversary of Grace's death, there was a large memorial service and celebration that Bernadette and other Ghost Seekers attended. They watched a wreath-laying ceremony at Punkey Bay, at the spot on the lake where Grace had been murdered. The Lady of the Lake was being remembered, and Bernadette felt her ghost among the collective mourners. When Bernadette and some friends stayed at the Big Moose Inn, they had a direct interaction with the ghost of Grace Brown. In the evening, the group went down to the lake and sat in the waterside gazebo. The entire group witnessed the entity of Grace form from mist into a ghost, right over the

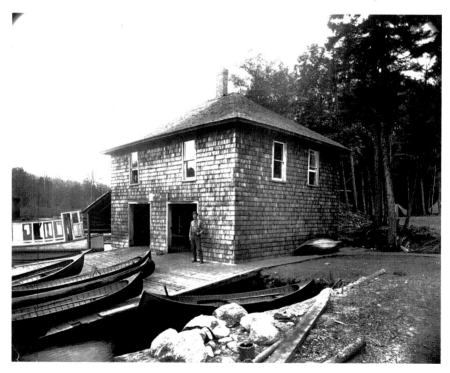

The boathouse at the Glenmore Hotel, where Chester Gillette rented the boat that would float him to the scene of the murder. *Courtesy Herkimer County Historical Society.*

The spot on Big Moose Lake where Chester Gillette landed his rented boat and fled the scene of the crime. *Courtesy Herkimer County Historical Society.*

water. The team was stunned and watched her over the still nighttime lake waters. This was proof of all who had said that Grace's ghost floats over the lake. It was not Bernadette's first interaction with Grace's ghost. The Ghost Seekers of Central New York conducted a paranormal investigation at the birth home of Grace Brown in South Otselic, New York, and had direct contact with her spirit. During the investigation, the Ghost Seekers had their digital recorders running. Bernadette asked Grace's ghost if she had been murdered by Chester Gillette, and the recorder picked up Grace saying, "Yes." It was a clear answer; the team was blown away, as it was an intelligent haunting and a direct answer from the other side from the murdered woman. Many times the Ghost Seekers have been asked if spirits can travel and haunt multiple locations. The answer is, absolutely. There is no doubt that portals are used by ghosts to move about, and Grace would naturally haunt the tragic place of her death but also the joyous family farm home in which she had been raised. If you get a chance, visit the water's edge of Big Moose Lake as the moonbeams hit the black water, and you might just catch a glimpse of the Lady of the Lake.

Bernadette's Take: This is a perfect example of a paranormal portal with ghosts moving between locations. I have been asked that many times in my ghost hunting career. Yes, ghosts can travel through portals from place to place. I encountered the spirit of Grace Brown at her home and at the place of her death. In our human form, we need modes of transportation to bring us from one location to the other, but spirits have no limitations on their travel. They can wisp from one location to another and therefore can be haunting multiple locations.

The Woods Inn

November 14, 2015—On the banks of Fourth Lake in Inlet, New York, there is a glorious hotel on the edge of the water that is not only beautiful but also paranormally alluring. The Woods Inn was originally built in 1894 by Fred Hess and operated under the name of Hess Camp. This was back in the days when the camp was serviced and guests delivered by steamboat. The building was sold to Philo Wood, who had been the manager for many years. He renamed the place the Wood Hotel, and from 1900 to 1920, he expanded the building and placed cottages and platforms for tents on the property. His run as owner would prove very successful, with many elite and famous people stopping by for mountain air and relaxation.

The hotel operated and flourished for many decades until it closed in 1989 after the death of the owner, William Dunay. The items inside the camp were sold, and it sat empty for many years until 2003, when a couple purchased the place and spent years upgrading and improving the Wood Hotel. They reopened the business in 2004, and it went by the name the Woods Inn. In 2014, Charlie and Nancy Frey purchased the hotel and added a lakeside café platform and pavilion. Of the original fourteen Adirondack-style hotels on Fourth Lake, only the Woods Inn remains as a year-round business. The grand hotel on the lake is not without its tragedy and is haunted. Ed is the name of the entity that strolls about the building and grounds. From 1903 until his death in 1905, Charles Edward "Ed" Duquette managed the hotel.

Electricity in the early twentieth century was snaking its way into remote areas like Old Forge and Inlet. The hotel installed a small power plant to brighten the hotel with electric lights. The power plant was located in a shed out back of the hotel, and one night when the lights went out, Ed went

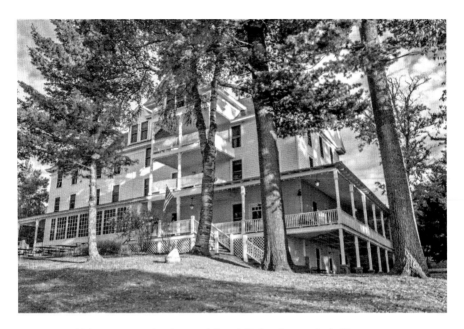

The haunted Woods Inn on the shores of Fourth Lake. *Courtesy Craig Clemow.*

out to check on it, lantern in hand. The shed had been described as poorly vented, so when Ed opened the door, an explosion occurred that critically injured him. Ed clung to life but ultimately died from his injuries. Almost one hundred years later, when the building was owned and being renovated by Joedda McClain and Jay Latterman, a figure was witnessed in the tavern. Many believed this to be the ghost of Ed. At this time, a mysterious figure in the form of ectoplasm was photographed, and many believe it to be in the shape of a man.

When old buildings are being renovated, it can stir up the spirits, either out of curiosity or pride in their old haunting ground being improved. In any case, the interactions with Ed increased, with staff reporting that they ocurred during the time of the remodel. After the update, there continued to be paranormal activity, with one hostess having been tapped on the shoulder when she was all alone in the inn. Charlie Frey said that a grandmother had been staying at the hotel with her granddaughters and called him up to their room, as they had been hearing unexplained noises. When Charlie was up there, he heard a whine and a high-pitched noise. He checked everything, but it was an unexplained phenomenon. Charlie told the guests not to worry, as Ed is a friendly ghost. Charlie has felt the presence of Ed many times while working alone at night.

Ectoplasm forming on the first-floor stairs of the Woods Inn. *Courtesy Adirondack Express.*

Charlie was kind enough to allow the Ghost Seekers of Central New York into the gorgeous Woods Inn to conduct a paranormal investigation to see if they could connect with the friendly ghost of Ed. The team headed up on a chilly night, with winter's first snow on the ti~~~ ~~~~ ~~~~~~~~ ~~~~~

The team was greeted by the caretaker, Don Gabler. When the team pulled up, we paused and marveled at the beautiful Woods Inn. We had a feeling that it would be a productive ghost hunt, and our premonitions would prove correct. In the car ride up, Helen was complaining of having a headache and talked about having dreams and visions of a female entity that had been jilted by a lover. David and Dennis walked the floors looking for camera placements, while Helen and Bernadette looked for places that would be paranormal hot spots. The rest of the team of Joe, Ed, Judi and special guest Bill Lemieux would be there shortly.

The team marveled at the sheer beauty of the rooms and the floors, all of which were done in spectacular fashion. David and Dennis were unloading the gear when Helen and Bernadette approached and said that one room from the three floors of rooms had made them very uneasy. They asked for the guys to walk the rooms and see if they picked out the same one. As they were walking around, David saw a white flash that was a ghost peering up at him from the floor below. This happened to him a second time on the floor just above. It was looking up through the stairwell. It happened so quick that David was stunned by the vision. At the same time, Dennis was walking up and down the halls, entering every room on all three floors. When he entered one on the second floor, his nose lit up with a foul stench. It was sulfur. Dennis felt uneasy, looked at the room number and sought out the ladies, who were in the first-floor dining hall setting up home base. Dennis walked up and said, "Room 206." Helen's face dropped, and Bernadette smirked and said, "We are onto something tonight." The room had been the exact one the ladies had identified as uneasy.

Right after this, the rest of the team showed up, and the team started the process of running wiring for the night-vision cameras. There would be six hard-wired into ghost central, including one in the basement bar, one in the dining hall, one shooting the stairs where the famous ghost photo had been taken and one down each hallway of each floor. Judi had run into the same white figure upstairs on her walk-through. She was going up the staircase to the hotel when she saw a figure in white with what she referred to as a "wisp" trail behind it. This was up on the third floor. She also had the vision of a young boy entity that was coming down the stairs and bouncing a ball. Judi walked the basement bar and had a sharp pain in her left arm and saw a vision of a female in there that had been associated with a death. And the feeling about room 206 was becoming common, as Judi, on her own, walked into the room, felt uneasy and had the vision of a young woman with long dark straight hair standing in the

bathroom. Joe was outside taking exterior photos when something down by the water creeped him out. Joe is a solid man who does not frighten easily, so it had to have been something curiously paranormal and unsettling for him to be rattled. There was no doubt that the place was haunted, and the investigation had not even begun. The team was ready to meet and greet the ghosts of the Woods Inn, so all gathered in the dining hall and clasped hands. The members bowed their heads, and Judi led the prayer of protection that asked the dark entities to stay away and protect the group from evil and bring forth the kind and good spirits of the night.

The first team would be Joe, David, Bernadette and Judi, while the second was Helen, Ed and Dennis. Bill spent the evening watching ghost central. Bill writes in a logbook so the team can go back later and verify or debunk any strange sightings. Don the caretaker was able to shut off all the lights except the ones in each floor hallway. Since it is a hotel, and for safety reasons, these lights can never be shut off. Although the Ghost Seekers stalk entities in the dark, many can be spotted in the day, as David had seen one earlier. It gave a creepy, quiet glow to the investigation. The hallway lights would prove to be a correct happenstance, as right away they helped prove a haunting. Helen, Ed and Dennis went upstairs to room 206, where the acrid, foul smell was spewing out into the hallway. This time, Ed confirmed, as he mentioned the odd odor. We did not have a handheld video camera, just old-school equipment like a handheld digital recorder, a gauss meter and a digital camera. Ed brought with him Boo Bear, a new device that is a cute brown teddy bear but registers temperature fluctuations, electromagnetic fluxes and speaks. This tool is to be used if the group thinks there's a child ghost in the vicinity. Many times, homeowners of haunted houses will comment that something would be playing with their children's toys. This is common; the Maxson House has a child entity that bangs on the child piano and plays with the stuffed animals in the store.

Helen sat in a chair, and Dennis and Ed settled down on the beds as the investigation began. Helen had felt a chest compression and ringing in her ears right at the same time Dennis had ringing in his ears. About seven minutes into the investigation, the team heard a distinctive growl in the room followed by a thump. Dennis decided to lie down on the floor and stare at the ceiling and within moments felt something touch his shoulders and breathe on his bare neck. Helen felt that the entity was not dark or demonic but rather nervous and anxious. At this point, Ed got cold, and Helen and Dennis started to shake, specifically in their hands. The group tried the Boo Bear, but nothing was interacting with it. Dennis smelled green apples, the

pleasant scent had replaced the foul odor. A few minutes later, Ed heard movement in the bathroom, and a chair in the room next door slid across the floor. Then the gauss meter slid across the dresser. This was witnessed by Helen and Dennis.

The trio decided to move along to the first floor to room 107, where some of the members had a feeling in there during the walk-through. The room felt light and optimistic. This is where the light on in the hallway proved fruitful. Helen sat in a chair facing the closed door, and all the team could see was a crack of light under the door. They had just sat down and started to reach out to the other side when Helen said she could see darkened footsteps under the door as if somebody or something were standing and walking past the door. She darted to the door and opened it, but there was nothing there. Later on, the group would listen back to the audio recordings, and when Helen asked if it were a male entity and if it was following the group, they received a harsh otherworldly voice saying, "Bullshit." Bill would mention later that nobody was on the hallway camera. Helen felt that there was a woman entity in the room named Rose. The entire team felt a thump as if something large had stomped down on the floor. The digital recorder picked up this thump. Helen again saw something moving in the hall, and yet again nothing visible was behind the door. Then Helen witnessed a ghost walking around the room, and the entire team could hear footsteps. These were captured on audio digital recording. It's quite clear when listening back to the recording, as you could hear footsteps on the wooden floor of the room. All of a sudden, the Boo Bear spoke and said the temperature went up and something touched it. Helen felt there was a young boy spirit in the room and was reaching out to him. Then the Boo Bear moved, as if the young boy ghost had tried to pick it up. Dennis mentioned that he saw the boy had died from tuberculosis. Helen was floored by this and said she had the same vision at the exact same moment. It was odd, as Helen is clairvoyant but Dennis is not, yet they seemed to be mentally interlocked on the investigation. A photo was taken at this moment and showed the door, the bear and Helen draped in spirit lights.

The first team of David, Bernadette, Joe and Judi went down into the basement bar. Right away Judi saw three entities, and Bernadette commented that the area was overflowing with spirits. Bernadette had the same feeling as Judi and Helen that there had been some kind of conflict and argument in the bar, with someone being punched. Right after Bernadette commented on these visions, Joe got chills all over his body, and Judi had a searing pain in her left cheek as if she had been punched. Moments later, the entire group

got what they described as a pleasant smell but didn't associate it with any particular item like the green apple paranormal odor the other team had been smelling. Then something very odd happened to Bernadette: she felt compelled to sing a song. She started to belt out the song, "A Tear in My Beer" and really couldn't explain why. She said that this has never happened to her before on an investigation, but it was the spirits putting in a song request and she was more than happy to oblige.

The members regrouped at ghost central and were talking about what had occurred when Bill mentioned that he saw a tablecloth move in the dining room. The static night-vision camera had picked it up, and Bill said there was nobody in the room at the time. The team tried to debunk, yet the furnace was not running, there were no air vents near the table and no doors or windows were open. This was great for the investigation, as the teams departed for round two. Helen, Ed and Dennis decided to go down into the basement bar, and it only took a moment for the team to see something moving behind the bar. Helen felt this was the spot of the woman she had visions and dreams about before the investigation. She felt the lady's name was Caroline and that she had been very sad as her lover or husband dragged her to the bar and had a great time. He was the life of the party, and she was miserable and downtrodden. Helen felt that Caroline, when alive, had long dark hair and a sad life.

After a while, the team moved to the game room, where there was a pool table. The team sat down, and after only a few minutes, Dennis and Helen felt compelled to go outside. Just outside the door, there is a brand-new pavilion that hosts weddings and concerts. The site was where the original town of Inlet post office had been located. It had been torn down years earlier, and the beautiful pavilion was now in the spot. It was not cold outside, and all that could be heard was the gentle waters of Fourth Lake splashing against the shore. The group went under the pavilion and within a minute saw an odd ectoplasm moving between a few buildings. It was not mist, fog, rain or snow, as it was a dry and clear night. It moved and acted like it was not of this earth. It was right after this that Helen and Ed started to ask about "Ed," the caretaker ghost that had died on the property more than a century earlier. The group thought it might have been Ed up in room 206, as the electrical smell coincided with his tragic death in an explosion while dabbling in electricity. Right after the group asked questions of the caretaker spirit, Dennis took a photo of Helen that shows her draped in ectoplasm. When blown up on a screen, multiple faces can be seen within the ghostly mist. Dennis walked to the back corner of the pavilion and took photos of

Ed and Helen from a different angle; in the photos, you can clearly see a large ectoplasm mist forming right behind Helen. This was not far from the spot where Joe had been creeped out earlier when he had been outside all alone, taking photos of the beautiful Woods Inn. The team went back inside and sat on the dining room porch, where Helen felt something touch her. She got a massive headache, and then the Boo Bear began to spew forth phrase after phrase in its tin synthetic voice that it was being tickled, it was being touched, that it was being communicated with. It was very odd and off-putting, as he was very sporadic throughout the night yet he exploded with animation on the porch.

The team of David, Joe, Bernadette and Judi decided to go up into the rooms of the hotel to see if the spirits were still active. The team went to room 206, and right away the sulfur smell kicked up. Judi commented that the female entity in the bathroom was not good. The team heard a knocking and then witnessed a cabinet door open and close all by itself. The team exited and went down a floor to room 107. Judi and Bernadette commented that the air was light and that a pleasant female entity was in there. They wondered if it could be the ghost of Rose, which the other team had met earlier in the night. Joe and Dave left the ladies alone for a few moments, and when they came back, Joe stated that he felt that something bad was walking around the hotel.

The very last round had David, Joe, Ed, Dennis and Judi go upstairs, where not much happened until they went into room 208. This was the room next door to the odd smell and the possible resting place of Ed the ghost caretaker. Things seemed relatively quiet until Dennis witnessed a large orb cross the room and settle on David. Dennis felt ill and fled the room. At the conclusion of this session, the team exited and found Dennis all by himself in the darkness of room 206, lying on the bed and holding his head in his hands. It was very unusual and highly unlike Dennis to flee a room. It was off-putting that he would flee to the room with all the anxiety of the spirits. The entire team marveled at the paranormal activity in such a wonderful and gorgeous setting. The Woods Inn is considered to be certified haunted by the Ghost Seekers of Central New York. Just don't be afraid to stay in room 206 or 107. You might get an unwanted guest hovering next to your bed.

BERNADETTE'S TAKE: I've long had a fascination with the Woods Inn and had been compelled to drive there once and just look at the building. It draws a person in with its beauty, and being adjacent to Fourth Lake makes it

attractive to ghosts. I was in awe of the spirits and their interaction with me and my team during the investigation. Seeing spirits walking the halls in the light was a rare experience to my team. We met the owner Charlie on the way out after the investigation, and he could not have been more gracious. I can see the ghost of Ed the caretaker being very pleased with the current owners and the loving care they are showing to the grand Woods Inn. I had never been asked by a ghost to sing a song. That was a unique experience, and I was thrilled to perform for the spirits.

RUSSIA UNION CHURCH AND SCHOOLHOUSE

NOVEMBER 9, 2013—The Ghost Seekers of Central New York are asked to give haunted presentations on the theories of the paranormal on many occasions. On a spring day in 2013, Bernadette and Dennis were at the college campus of SUNY Polytechnic in Utica, New York, doing a presentation on "Haunted Mohawk Valley" when they were approached by a sweet little old lady, Nancy Crisino, who wished to speak. Little did they know it at the time, but this chat would lead to one of the most active and scary investigations in the documented history of the Ghost Seekers. Nancy showed a picture taken outside a church that showed ectoplasm swirling with faces within the mist. She also gave us a copy of an old church postcard that had a code scribbled across it that had gone unsolved for more than one hundred years. Joe broke the code, which was Masonic in origin. The postcard translation provided the following correspondence: "Dearest, Just a line to let you know we are well. Well I will look for you but it has been an awful storm. Hope this will find you all the same with love from your old Aunt. Write soon."

We decided to go up to the church and do a walk-through to see if it would be worth investigating. Bernadette, David and Dennis went on a sunny August afternoon. The drive was through the towns of Newport and Poland and then up in the hills to where the church sat. It was a winding country road reminiscent of another century. We walked through the church and the separate little one-room schoolhouse and instantly got the feeling that an investigation in the farm country would yield paranormal fruit. Bernadette got a bad feeling from the back room in the schoolhouse, and the K2 meter spiked to confirm that ghosts were present. The church is being refurbished back to its original condition, including repurposing the original glass with modern framing. The structure is old but solid and very beautiful

Ectoplasm outside the Russian Corner Church. *Courtesy Tom and Debbie Zembrzuski.*

The pews are arranged in very peculiar configuration, and when asked, we were told that the church had been shared by many denominations, so the pews had to be arranged to accommodate their religious ceremonies. The church had hosted the following faiths: Presbyterians, Baptists, Free Baptists, Episcopalians, Methodists and Universalists. The construction on the Russia Union Church started in 1819, but it was dedicated in 1820, making it one of the oldest structures the Ghost Seekers of Central New York has ever investigated. When it was completed, a man by the name of William Walters was up on the steeple and swung a bottle of brandy three times before smashing it and dedicating the structure. The schoolhouse was added later in the nineteenth century. The church also hosted many community events and served as the town hall.

The night of the investigation was a crisp, cold night in November yet not too frigid. We carried the equipment in, excited to be the first to investigate a wonderful old church. We made ghost central right inside the foyer of the church and snaked wires to the night-vision video cameras throughout the church, as well as a few down in the front yard and into the one-

Postcard of the Russia Union Church. *Courtesy Russia Civic Association.*

room schoolhouse. When the Ghost Seekers perform an investigation, we tend to run a lot of equipment in the hopes of capturing something paranormal. There's a lot of walking through and setting up, and we tend to place cameras where there was either reported ghost activity or just the gut feeling our investigators get on the spot. It was during setup that something potentially dangerous happened. Most of the seekers were near ghost central, and Bernadette had been upstairs in the church. We could hear her walking down the wooden steps in a loud and slow *clunk*, one step at a time, when all of the sudden there was a loud crash at the bottom. We rushed into the room to find Bernadette on the floor at the bottom of the stairs. She had been walking down them when a pair of invisible ghost hands shoved her from behind, sending her tumbling. She was lucky that she was only four steps up, but still her ankle would swell that night; to this day, she has pain from her paranormal encounter. This would not be the last time she'd be victimized on this ghost hunt. The team finished setting up the gear and got together in a circle to say the opening prayer of protection. That night, we had Len, Carol, Bernadette, David, Dennis, Ed, Josh, Joe and Irene. The prayer would come in handy, as we would end up dealing with the nasty ghost that had pushed Bernadette.

Round one of the investigation had two teams, with Len, Bernadette, Irene, Helen and Joe going down to the schoolhouse and Paranormal Ed, David, Josh and Dennis going into the first floor of the church. Carol was watching ghost central and chronicling the happenings on the video cameras. The group going into the schoolhouse engaged in a paranormal battle with the grumpy entity, which Irene determined was an older teenager that had been the bully of the schoolhouse more than a century ago. Helen felt his presence and came up with the name Alfred, and the ladies grouped their psychic energy together to glean a view of this teenager, which they felt had terrorized the other children in the schoolhouse. He was a bully in

his mortal life and an ogre in the afterlife. This was not demonic or dark energy—it was a nasty ghost. Bernadette has a theory that ghosts are as they were in life: grumpy, shy, friendly, curious and possibly evil. It was right at this time that Len had gone to his vehicle to retrieve a ball that was going to be used as a trigger object; he saw a shadow figure ducking behind one of the vehicles parked in front of the church. He approached and tried to engage the curious ghost when it darted away.

Back inside the schoolhouse, the group was in the pitch dark with the recording devices and cameras capturing the events when Joe witnessed a dark shadow person in the back room where the kitchen now resides. According to Nancy, that had been a back woodshed long ago, but in our modern time, it had been converted to a working kitchen. The energy got dark, and Helen felt in danger so she walked out of the schoolhouse. It's rare for any investigator of the seekers to leave an area while things are underway; however, she had a feeling of dread. While this was going on, Dennis, David, Josh and Ed were sitting in the pews of the church and did not produce much except a few small orbs on digital photography. When the group went up to the second floor, it picked up when the gauss meter pegged all the way, Dennis witnessed something walking and Josh heard the footsteps. Josh had mentioned that the air felt light, but that would change in the next round. The group reunited at ghost central and discussed what each had experienced. After a quick snack on food, the teams were ready for the second wave of paranormal encounters.

For round two, the teams would remain the same, but this time, the intensity increased with both teams. David, Josh, Ed and Dennis used the spirit box in the schoolhouse. This device goes through radio signals and plucks out words that come from the other side, many times with intelligent answers to earthbound questions from us mortals. This spirit box session was the most incredible in all the times the device had been used. It was so dark in the schoolhouse that you could hold your hand in front of your face and not see fingers. The spirit box has a small red bulb that is the only source of light. The device started clicking, and the group asked questions in the back kitchen area. Josh asked if there was a young boy present, and a solid "Yes" came through. Then an insidious growl came through the device. Josh asked, "Do you live to be in control?" and a response came, "Talk to me." Josh asked what the little girl's name is, and the box came out with "Irma." When he asked what the little boy's name was, the spirit box said, "Nelson." Dave then asked, "Is that you, Nelson?" and the box spewed forth, "F—K Y-U!" in a very stern response. Then Dennis said, "You're so smart, finish

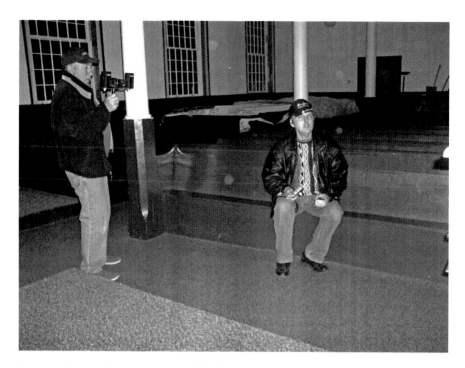

Dave holds the night-vision camera while Ed asks questions of the spirits.

this word, C-A-," and the spirit box said, "T." The group remained calm as we were doing battle with the other side. Paranormal Ed then asked, "How about this one, C-O-W-A-R," and the spirit box responded, "D." The responses slowed down, but then we got a flurry of words like "freak," "stupid," "Dick" and then the name "Mr. Oz." We wondered if Mr. Oz had been a teacher or if this spirit was playing a game with us. The air had an electric scent like the aftermath of a lightning storm. The last thing the group did was place a flashlight down and ask the spirit to do something and turn it on. The beam flashed to life in a very strong way, and the members of the group could see the astonished looks on one another's faces in the haunted schoolhouse.

The most dramatic and frightening event happened in the first and second floor of the church, where Len captured the entire exchange between Bernadette and her ghostly nemesis. Joe, Bernadette, Helen and Len had walked into the first floor and sat in the front pew. The group determined that the entity had been the same Alfred that had harassed them in the schoolhouse. He had followed the team, and right off the bat, Len, who is

normally very easygoing and professional, lost his temper and said to Alfred, "You drained my battery, you son of a bitch!" Then Irene said, "You're all talk." Then Joe requested the entity to "do something." This is way off the norm for the Ghost Seekers, but Alfred had been poking and prodding the group all night and some members had had enough, especially after seeing Bernadette injured by the angry young male ghost. Josh had earlier had the vision of an older, large teenage boy that terrorized the children in the late nineteenth-century schoolhouse, and his bullying had been ongoing, as his father was some kind of authority figure in the church or the community. The difference this time was that Alfred had adults capable of fighting back. Helen kept telling Alfred to go away and not to come near her.

The group picked up footsteps and movement all around but not close. Bernadette commented that she couldn't believe Alfred was pulling this in a house of God. Helen felt that he was trying to get to Bernadette. Bernadette responded with, "Do something, creep." The group left the area, with Len and Joe going into the basement. It was quiet down there, so the entire group then moved up to the second floor, where they were joined by Josh. For a while, the team commented about how light it felt upstairs without Alfred around. There was soft laughter, but the fun would not last, as Len's REM pod pegged all the way and the K2 also went to the highest reading. The theory is that entities are near the devices and cause the unnatural spikes. It was an intelligent haunting, as Len kept asking the spirit to come back and make the devices peg upward, and it happened numerous times on command. At this point, Helen said she felt pressure on her head and her ears were stuffing up. Helen stated that she felt Alfred come into her body, and it was at this point that she started talking in two distinct vocal tones. It was a possession, as she started spewing filth toward Bernadette; Irene stepped in, and the spiritual battle was underway. Alfred, speaking through Helen, kept telling Irene to shut up. The battle went back and forth, with several nasty exchanges before Alfred exited and fled. At this time, a shadow person was picked up on the night-vision video camera. The entire group saw this, and it was verified on tape. This was right at the time when Joe heard a distinct growl right behind him. Dave and Dennis saw the shadow person moving in the corner on the camera, which was on the tripod, so it was a double verification. On tape, the figure looks like the grim reaper and is shifting from left to right. Partnered with the possession of Helen, it made for a frightening spectacle, even to longtime hardened ghost hunters.

At the end of the night, Dennis and Ed decided to go up into the high bell tower, take some photographs and do a quick EVP session. They had

been up there earlier and scanned everything very thoroughly. This time, Ed took a photo that had a large ectoplasm in it, and in the area there was an axe that had not been there earlier. The team had joked earlier that the spirits were looking to chop into Bernadette with an axe. This was right after she was pushed, and the possession of Helen had proven that the angry spirit did not want Bernadette on his turf. It was bizarre and unthinkable that the axe had been placed there, as the entire group had climbed up into the church bell tower that evening and the axe had not been there. Nobody else had been in the church, yet there it was. When it was discovered by Ed and Dennis, the digital recorder picked up a ghost whisper from the other side. The group decided unanimously that the Russia Union Church and schoolhouse has to be one of the most haunted sites in New York State and probably the country. It is not demonic, though; rather it is ruled by a single angry young male spirit. The night proved to be one of the most intense and thrilling ever experienced by the Ghost Seekers. The closing prayer was intense and emotional, as the group held hands in a circle and prayed that Alfred and any other dark entities would shed their attachment to us and stay in their realm.

BERNADETTE'S TAKE: This is the first time in my ghost hunting career that an entity lashed out at me. To this day, and probably for the rest of my life, I will have a limp from my injury from being pushed down the stairs by the angry ghost of the Russia Union Church. Who says ghost hunting isn't a contact sport?

ADIRONDACK MANSION

SEPTEMBER 27, 2014—The old structure, on the edge of the blue line of the Adirondack Mountains, at one time had been a post office and hotel for the town residents, as well as travelers going back and forth from Utica and the Mohawk Valley on their way into the heart of the mountains. The Ghost Seekers of Central New York fell in love with this building, dubbed the Adirondack Mansion, but also picked up one of the best EVPs ever recorded in the annals of spiritual safaris. The mansion had once been a store, post office and overflow for hotel guests. It had also been the living space of the family running the store and post office. On the campus, there is also a small icehouse and a wooden ba... :' ^ second floor

woodshop. The building is now empty and up for sale. It was clear on the pre-investigation walk-through that the mansion needed some updating. The group had been approached by part owners Kristy and Dave to go in and investigate. They had many tales of ghosts and unexplained events. Dennis had stopped by to scope out the structure, and during a brief tour with Kristy and Dave, he felt very warm and welcomed by the spirits of the mansion. He took a few daytime photos that showed strong spirit lights hovering around the couple.

On a warm September evening, the Ghost Seekers anxiously arrived at the Adirondack Mansion, ready to meet the ghosts of the property. They were met by Kristy and Dave, who offered bright smiles and firm handshakes. The team on the investigation included Bernadette, David, Helen, Dennis, Irene, Paranormal Ed, Josh and Len. Kristy and Dave gave the group a tour and the rundown on the history and mentioned that Dave's grandmother had run the general store and lived in the home until she was ninety-six years old. Dave mentioned that his grandfather had passed away in the kitchen of a heart attack. The post office had been run out of the mansion until 1997. The structure was completely empty, but the love was in the air. You could tell the paranormal activity was one of hope and light. The group was eager to run the lines and start the investigation. It was during the setup that David saw a shadow person duck and hide through the side entrance to the mansion, and Josh took a very odd picture in a mirror in the living room. It's a great sign when you see a ghost before the investigation begins. Static night-vision cameras were set up in the post office, the mirror room, the first hall and stairs and the second-floor room and hallway. The outer woodshop and icehouse had to be filmed with hand-held night-vision cameras, as it was too far to run wiring.

It took about an hour to set up all the devices, circle for our opening prayer and begin the investigation. Kristy stayed and sat in on ghost central with Dennis, as the first team of Len, Helen and Josh went to the first floor, while David, Ed and Bernadette went to the second floor. Ed picked up white orbs on his camera, but the empty mansion proved to be an echo chamber, with both teams spilling over to each other. It made the EVP session difficult. One interesting occurrence was when Kristy and Dennis were at ghost central and saw a shadow figure fly right over their heads. Ghost central had been set up in the kitchen of the mansion. The second round proved more fruitful, as the teams split in two, with one going to the outside woodshed, while the other remained in the mansion. The second go-around featured Bernadette, David, Dennis, Kristy and Ed. They went up to the second floor, and in

Left: The highly haunted Adirondack Mansion.

Below: The garage with the woodshop behind the Adirondack Mansion.

every digital photo taken, there was a flock of spirit lights and orbs hanging around Kristy. It's as if the long-passed relatives were paying her a visit and escorting her around the mansion. The EMF detector was spiking, and we captured a strange paranormal smear on camera next to Kristy. David's handheld digital night-vision video camera kept going in and out of focus. It was as if Kristy was bridging the gap between the living and the dead.

The best evidence of the night and best EVP happened when Irene, Len and Josh went out into the woodshed. Up on the second floor, there was a woodshop that Kristy and Dave had said was the grandfather's sanctuary. Nobody had been allowed to go up there and disturb him. The shop now is a few empty wood benches and a wooden bench vice. The group was carrying a small digital recorder, and Len had his night-vision video camera on his shoulder. As they climbed the crooked wooden steps up into the second-floor workshop, a loud "huff" is heard on the recorder followed by the voice of an elderly man saying, "What are we doing here?" This ghost voice was also captured on the video camera, which is double verification of a voice from the other side. The group listened to this interaction play back in stunned silence. There is no doubt that the Adirondack Mansion is haunted. It's haunted in a good way, though, by spirits of those who lived and worked in the grand old structure. The spirits were happy to have company, and the Ghost Seekers were honored to have been included in their otherworldly ruminations.

BERNADETTE'S TAKE: The entire group has a warm place in its heart for the mansion. It's rare for us to conduct an investigation in an empty home and have it proved to be an active but loving place. I enjoyed Kristy and Dave inviting us to investigate the mansion and know that whoever lives in the place will love it as much as the Ghost Seekers do.

EQUIPMENT IN THE FIELD

The Ghost Seekers of Central New York use many types of devices and electronics in their quest to communicate with those not of this celestial dimension. The list here is the rundown of the gear we use in our ghost hunts. These are valuable, but nothing replaces our five senses, our hearts and our minds.

digital camera: One of the basic-function tools of every investigation is a camera. They can be used not only for detecting paranormal activity but also for documenting your investigation. Digital cameras are the easiest to use because you can transfer high-quality photos directly from a digital camera right to your computer. You can get cameras that are modified to see in the infrared spectrum of light or full-spectrum cameras that can see in the ultraviolet, visible and infrared spectrums of light at the same time.

handheld video camera: Video cameras are an important instrument for an investigation. Unlike still cameras, they provide us with constant visual and audio surveillance for review and observation. The video cameras we use are equipped with infrared capability, and this is the mode we use. With video, any phenomenon occurring can be documented in its entirety. This will show the length of time the phenomenon occurs, what is happening, the conditions surrounding the phenomenon and possibly even the cause of the event.

DVR/video (night-vision) camera systems: DVR systems with night vision can be a powerful way to capture great paranormal evidence. Using multiple cameras, you can record and cover large areas for long periods of time with one easy setup.

digital voice recorder: Digital audio recorders, a more recent technology, use internal memory to record audio. This gives you the ability to record for many hours depending on the size of the internal memory. They are typically very small and include a way to plug the device into your home computer to retrieve the audio data—typically via a USB connection. This audio is typically in a standard format such as MP3, WAV or WMV—again, depending on the type of recorder you get. Digital voice recorders are without a doubt one of the most important pieces of equipment that you should have. Audio recorders are a handy tool not only for recording EVP (electronic voice phenomena) but also for documenting your investigation.

EMF detector: EMF meters measure fluctuations in electromagnet fields (or EM fields). These fields are a direct result of electrical appliances in home, cellphones, power lines outside and even fluctuations in solar activity and weather. Beyond that, a primary theory in the paranormal world is that entities can manipulate these fields in their attempt to manifest themselves or interact with our world. The units of measurement registered on an EMF meter are called milligauss. When using the EMF as a tracking device, look for fluctuations of 2.0 to 7.0; this usually indicates spirit presence. Anything higher or lower is normal and has a natural source.

spirit box: Is a great tool for trying to communicate with paranormal entities. It uses radio frequency sweeps to generate white noise, which theories suggest give some entities the energy they need to be heard. When this occurs, you will sometimes hear voices or sounds coming through the static in an attempt to communicate. You can get intelligent responses from the spirits using this device.

flashlights: It is recommended to always keep a flashlight with you for safety purposes. A red lit flashlight helps to preserve your night vision and can be used as a tool to communicate with the spirits by asking them to turn the flashlight on and off to answer investigative questions.

spare batteries: Remember to bring spare batteries for everything. Due to spirit activity, batteries often run down very fast, as the spirits use the energy from the batteries to manifest themselves.

first-aid kit: For any unexpected emergency. We've had paranormal interaction that results in spills and falls, but tramping around in the dark can also result in slight injuries, including scrapes, cuts or ghostly bruises and scratches.

notebook with pens and pencils: You need to write and log in everything that happens. If you don't, then you really don't have much research information. An example of this occurs when one investigator gets an EMF reading that's high but never writes it down. Another investigator takes a picture of the same area but is not aware of the reading and gets an anomalous image. Without that EMF reading, the picture may be good evidence, but with a report noting the reading, the picture's value as evidence greatly increases. Many investigators use a digital recorder.

jackets or weather-appropriate clothes: If you are cold, you are not at your best, and your observation skill could suffer.

watch/clock: Logging in the times that events occur, as well as your arrival and departure, is extremely important.

compass: When used during an investigation, this will indicate spirit presence when the needle cannot come to a precise heading or spins/moves erratically. This works on the same principle as an EMF meter.

motion detectors: These can be used to sense movements by often unseen forces or spirits.

laser grid: This emits a grid of green or red dots useful for detecting shadows or general visual disturbances during an investigation. Set it in front of a running camera to catch potential evidence.

mel meter: When you need to measure EMF and temperature, you need one device that gives you a wealth of information and lots of options. This device offers both single-axis AC magnetic field measurement and real-time air temperature readings.

REM pod: Uses a mini-telescopic antenna to radiate its own independent magnetic field around the instrument. This EM field can be easily influenced by materials and objects that conduct electricity, based on source proximity, strength and EM field distortion.

thermometers: These instruments are also very useful. There are two types used: regular digital thermometers and infrared non-contact thermometers. When used during an investigation, this will aid as a detection system for spirit presence. Rapid temperature drop of ten degrees of more could indicate spirit presence.

handheld radios: These are very useful in large outdoor areas and buildings with groups spread out in various rooms. They could be great in emergency situations or just to rotate groups. Be aware that they could interfere with your EVP recording.

GHOST HUNTING PROTOCOLS

During a fleeting glimpse of the paranormal world, the world beyond appears to be uncertain. Opening our minds to the existence of ghosts is always rewarding. If ghosts are the personalities and temperaments of people who once lived and decided not to cross over to the other side at the moment of their death, wouldn't these spirits then reflect their former lives? According to the laws of physics, the data being received should not exist, but the paranormal is governed by a distinct and different set of rules—rules between space and time, rules between matter and energy and how these concepts interact to create a universe in which all of nature exists. For the entities that operate in *this* realm, the rules become simple and certain. The dedication to finding the truth is opening the mind to the existence of ghosts. The gap is narrowing when that happens, and the uncertain will be certain. Every day, a new encounter or experience should cause us to reevaluate the world of ghosts. When the members of the Ghost Seekers of Central New York conduct their spiritual hunts, they use strict rules of ghostly engagements in order to ensure accurate and solid evidence of the paranormal. We do not guarantee that anybody will encounter ghosts, but using the required equipment and these rules will help you conduct a solid ghost hunt. The Ghost Seekers of Central New York feel that having an open mind, peaceful harmony and good team karma seem to coax the spirits out of their hiding spots. If you seek to chase ghosts, then these rules will assist you:

- Pray and ask the spirits of the dead for permission to take their photos or to record their voices.

- Respect posted property, ask permission and do not trespass. Act professional.

- Show reverence and respect in cemeteries, battlefields, historic sites and so on.

- No running or horseplay in cemeteries or historical sites.

- A positive mental attitude is very important for all investigations.

- Follow the lunar cycles and solar storms for conducting investigations for best results. Paranormal events occur during peak geomagnetic field conditions.

- Do not take photographs during adverse weather conditions, such as rain, mist, fog, snow or windy or dusty conditions.

- Remove or wear the camera strap so it does not hang loose.

- Take photos of dust particles, pollen and moisture droplets to see how they appear.

- An orb is not special or unique. An orb is only a description of shape. Most common orbs are airborne dust particles. Multiple orbs in photos are almost always dust particles, never spirits.

- Do not take photos from moving vehicles or walking on dusty roads.

- Remove all dust, spots and fingerprints from camera lens.

- Avoid shooting with flash at reflective or shiny surfaces.

- Keep fingers and long hair away from the lens of the camera.

- Avoid shooting when foreign objects are floating near the camera.

- Flash is only good for nine to twelve feet from the camera, so focus on that range.

- After twenty minutes, the spirits will get bored; there is no need to record longer in one area.

- Do not rub the side of the recorder while recording nor walk while recording. Stand still to record.

- We do not consider Ouija boards, dowsing rods or pendants valid investigation tools.

- No smoking, drugs or drinking during an investigation.

- If someone is angry, they should not be involved with an investigation. They will draw angry spirits, and the other spirits will avoid them.

- Use mediums and psychics with caution, as they are only a tool and their channelings must be verified with recordable evidence.

- Use the rule of paranormal investigator Josh Aust, who stated the reason for our success: "an actual deep sensitivity of the spiritual realm instead of just a willingness to know." Being open-minded and of good intentions will increase your chances of communication with the dead.

GHOST INVESTIGATIONS

If you feel you are in need of a ghost investigation, please feel free to contact us through our website (www.cnyghost.com). We specialize in paranormal research and investigations. The Ghost Seekers of Central New York are not demonologists, but we can guide you to those who can assist if you are receiving dark or demonic hauntings. You must be very careful who you allow into your place of haunting, as a naïve or unprepared paranormal investigator can agitate or make worse your dark hauntings. We always open and close every investigation by standing in a circle, holding hands, bowing our heads and reciting a prayer of protection. We also believe in giving back. The Ghost Seekers of Central New York conduct many charity events for historical societies and places of prominence looking to raise funds. We are a group that enjoys helping others, so please feel free to contact us if you think we can assist you or your event.

SOURCES

Adirondack Mountain Productions. *The Strand Theatre: 90 Years in Old Forge.*
http://vimeo.com/71233461.

Boonville Herald. "Thomson Theatre Opens." March 15, 1923.

Brandon, Craig. *Murder in the Adirondacks: An American Tragedy Revisited.* Utica,
NY: North Country Books, 1986.

Byron-Curtiss, A.L. *The Life and Adventures of Nat Foster Trapper and Hunter of the
Adirondacks.* Utica, NY: Press of Thomas J. Griffiths, 1897.

Cohen, Linda, Sarah Cohen and Peg Masters. *Old Forge: Gateway to the
Adirondacks.* Charleston, SC: Arcadia Publishing, 2003.

Ghost Seekers of Central New York. "Rules and Protocols of Ghost
Hunting." www.cnyghost.com.

Goodsell Museum. The Town of Webb Historical Association. www.
webbhistory.org.

Grow, Brittany. "The Woods Inn and the Van Auken's Inne Seem to Have
an "In" with Paranormal Guests." *Adirondack Express,* October 27, 2015.

Herr, Charles. "The Founding of the Town of Webb." *Adirondack Almanack,*
April 22, 2014, www.adirondackalmanack.com.

———. *Nathanial Foster Jr. and Peter Waters: The Story of Two Graves.* N.p.: self-
published, 2010.

History of the Old Forge Hardware Store. www.oldforgehardware.com.

Masters, Peg. *History of the Old Forge Fire Department: 100th Anniversary, 1907–
2007.* N.p.: self-published, n.d.

Masters, Peg, Town of Webb Historian. "Mary Doolan's Cure Cottage for Consumptives." N.p., n.d.

Post Standard. "G. Harry Brown Dies; Old Forge Businessman." Friday, August 3, 1962.

Rome Sentinel. "Services Planned for Myrne Moose." Tuesday, August 29, 1944.

Russia Union Church 110th Anniversary, 1820–1930. Poland: New York Ancestry, 2003.

Webster, Dennis. *Wicked Adirondacks.* Charleston, SC: The History Press, 2013.

York, Michelle. "Century After Murder, American Tragedy Draws Crowd." *New York Times,* July 11, 2006.

About the Authors

Courtesy Rick Surprenant.

B ERNADETTE PECK is the founder and leader of the Ghost Seekers of Central New York and has been investigating the paranormal for more than three decades. She's the coauthor of *Haunted Mohawk Valley* and *Haunted Utica* and makes her home in central New York. She can be reached at dpecksr@twcny.rr.com.

D ENNIS WEBSTER is a certified paranormal investigator with the Ghost Seekers of Central New York. He's a motivational speaker, writer and student of life. He has a Bachelor of Science degree from Utica College and a Masters of Business Administration (MBA) from SUNY Polytechnic. He makes his home in central New York, on the edge of the blue line of the Adirondack Mountains. He can be reached at denniswbstr@gmail.com.